IMAGES
of America

AFRICAN AMERICANS
OF JACKSON

ON THE COVER: The student choirs of Smith Robertson School, c. 1950, pose in front of the main entrance to the school named in honor of a prominent businessperson who operated a successful barbershop. Smith Robertson was born in 1847 during slavery; he became the first African American elected as an alderman in the city of Jackson. The present building, with its art deco facade, was renovated in 1929 by the prominent architectural firm Hull and Mulvaney. (Courtesy of Smith Robertson Museum Archives.)

IMAGES
of America

AFRICAN AMERICANS
OF JACKSON

Turry Flucker and Phoenix Savage

ARCADIA
PUBLISHING

Published by Arcadia Publishing
Charleston SC, Chicago IL, Portsmouth NH, San Francisco CA

Printed in the United States of America

Library of Congress Catalog Card Number: 2007934713

For all general information contact Arcadia Publishing at:
Telephone 843-853-2070
Fax 843-853-0044
E-mail sales@arcadiapublishing.com
For customer service and orders:
Toll-Free 1-888-313-2665

Visit us on the Internet at www.arcadiapublishing.com

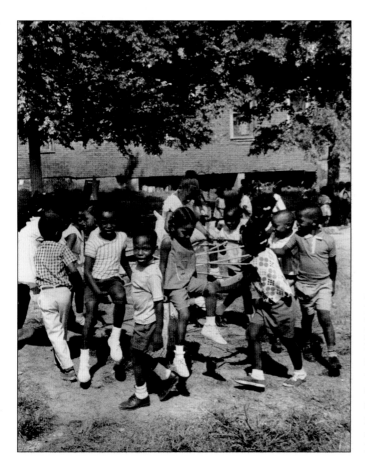

MERRY-GO-ROUND. School-age children are playing on a makeshift merry-go-round made of a large, wrought iron wheel mounted on a tree stump, while younger students line up to return to class. (Courtesy of Smith Robertson Museum Archives.)

CONTENTS

ACKNOWLEDGMENTS

This project could not have been possible if it were not for the encouragement and support of Austin J. Sonnier. We would like to thank Yolanda Flucker and the Savage families for always being a constant source of inspiration and love. We would also like to thank Jacqueline Wheelcok for editing portions of this book and providing constructive criticism and support.

We are extremely grateful to the following people for sharing their personal photographs and providing useful information about African Americans in Jackson: Tanya Britton, Camilla Britton-Lewis, Dr. Albert Britton Jr., Barbara Beadle Barber, Theresa King, Ruth O. Weir, Martha Anderson Handy, Sarah Dave, Darius Omar Williams, the Honorable Rueben V. Anderson, the Honorable Harvey Johnson Jr., Dr. Jerry Washington Ward Jr., and William Dickerson-Waheed. Special thanks to Lawrence Clark, Maxine Jackson, and Gregory A. Jones. Each one of these people provided invaluable support for this project.

We would like to acknowledge the following curators, archivists, and photographers that so graciously shared their collections in their respective archives: Latoriya Phillips, curator, Smith Robertson Museum and Cultural Center; Minnie Watson, Tougaloo College Archives; Debra McIntosh, college archivist, Millsaps College; Jeff Rogers, photography curator, Mississippi Department of Archives and History; Celia Tisdale, audio-visual curator, Mississippi Department of Archives and History; Clarence Hunter, curator, Tougaloo College Civil Rights Collection, Mississippi Department of Archives and History; Roland L. Freeman, photographer, and Tammy M. Hampton, archivist, the Vivian Harsh Research Collection of Afro-American History and Literature of the Chicago Public Library; and Burton Doss of Malaco Records.

INTRODUCTION

By the 1830s, African Americans were becoming permanent residents of Jackson. The building of the railroad from Jackson to Brandon with the labor of 140 enslaved Africans was the nucleus that created opportunity for future African Americans to settle in and around Jackson. Spurred on by the boundaries created from Jim Crow segregation, African Americans built and maintained social and economic institutions with Farish Street as the central hub of these activities. Placed on the National Register of Historic Places in March 1980, the Farish Street Historic District represented the largest economically independent African American community in the state of Mississippi. The African American community of Jackson comprised an eclectic array of architectural styles reflective of the economic and social stratification of its urban dwellers.

Spirituality serves as the core of the African American experience of triumph. In Jackson, Mississippi, the oldest African American denomination, Mount Helm, founded in 1867, gave spiritual strength to its congregants, enough so that they founded Farish Street Baptist Church, which later served as both spiritual and political sanctuary during the apex of civil rights activities. Jackson is replete with spiritual diversity. Holy Ghost Catholic Church was founded at the beginning of the 1900s followed by Christ the King Catholic Church. Holy Ghost was a generous donation on the part of Mother Katherine Drexel, heir to the Drexel fortune that built Drexel University of Philadelphia, Pennsylvania. Mother Drexel founded the order of the Sisters of the Blessed Sacrament. The presence of both Holy Ghost and Christ the King Catholic Churches provided African American parishioners with the foundations of the Roman Catholic faith. Charles Mason and Charles Jones met in the late 1800s; their mutual desire to minister to the faithful would lead to the formation of two distinct churches. Mason is credited with the founding of the Church of God in Christ (COGIC), and Jones is credited with founding the Church of Christ (Holiness) U.S.A. The roots of gospel music are found in the Church of God and Christ, one of the first African American denominations to merge sacred and secular music forms embedded with deep African rhythms and instrumentality.

As African Americans of Jackson made a joyful noise unto the Lord, they also tended to their economic needs by establishing service-oriented businesses that catered to their community. Entrepreneurship offered freedom from low-wage employment and a buffer from the insults of a Jim Crow society. Owning and operating their own businesses extended pride, dignity, and more importantly being one's own boss in an era that prided itself on owning and managing African American laborers; it was a mark of self-directedness of one's own destiny. It is ironic that the African American community of Jackson is best known for its long-standing traditions of economic engagement, from Dotty Cab, an African American–owned transportation company, to Big Apple Inn, famous for its pig ear and smoke sausage sandwiches. African Americans did more than just getting by; they initiated inter-generational institutions of commerce that began immediately after slavery and lasted well into the 1970s. The newspaper published in 1927 by Percy Green originally to address postwar issues as *Colored Veterans* became the *Jackson Advocate* by 1938 and is still in operation.

The best of any job historically belonged to African American men who held U.S. postal employment. The steady pay and government system of seniority granted stability in an unstable environment. Carsie Hall and others used their jobs as springboards into other professions. Hall and R. Jess Brown were for many years the only African American lawyers in the state of Mississippi. Both men, while in practice independent of each other, were active civil rights attorneys in Jackson.

In every African American community, education and civil rights coexisted as harbingers of human dignity. To decide which is more important is to ponder the unanswerable question of which came first, the chicken or the egg. Since slavery, African Americans have fought for both with each simultaneously holding center-stage positions as African Americans de-enacted their status as second-class citizens in America. At the turn of the 20th century, African Americans of Jackson attended no less then a half dozen private educational institutions. The significant efforts placed upon civil rights came at a price most often paid in the physical pains of beatings and in some cases death. Some of the names of the earliest freedom fighters may be lost, but it is important to recall those we remember. Gladys Noel Bates and R. Jess Brown initiated the first civil rights legal case to equalize teacher salaries, and in turn, Bates was blacklisted from teaching in Mississippi. The Tougaloo Nine simply but bravely wanted to read in a library, Anne Moody and her colleagues received an avalanche of condiments poured on their heads, and there were scores of unnamed freedom riders and protest marchers.

The late performer Nina Simone understood the power of art as a tool for change. Combining music and politics, Simone penned her civil rights anthem "Mississippi Goddam" to bring awareness to the racial injustices taking place in Mississippi and the American South. The Jackson community of visual artists, writers, and performance artists has given the nation unequaled talent, from the writings of Jerry Ward to the music of Cassandra Wilson. Local arts advocate John Reese saw the need to promote jazz studies in the public schools. He and other art advocates promoted African American culture in Jackson, which sparked an arts movement celebrating the life, history, and culture of African Americans in Jackson and the United States.

The pages of *African Americans of Jackson* illustrate through vintage photography the lives of the city's African American population as seen through their struggles and triumphs. From the early period of education and intramural sports to the everyday man and woman marching in tribute to the slain civil rights leader Medgar Evers, theses images depict a proud and progressive community.

One

GOING TO MEETING

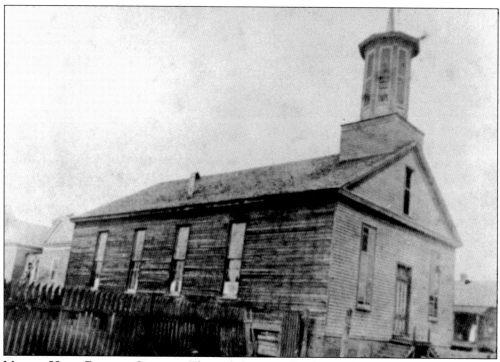

MOUNT HELM BAPTIST CHURCH. The early history of Mount Helm Baptist Church was born out of the First Baptist Church of Jackson, Mississippi. The First Baptist Church was organized in 1835. Prior Lee, a prominent white citizen in Jackson and a man with deep religious convictions, persuaded the congregation at First Baptist Church to allow African Americans to worship in the basement of their church. In 1867, the year of ratification of the 13th Amendment to the Constitution abolishing slavery, African Americans withdrew from First Baptist Church and erected their own church, which was named Mount Helm Baptist Church. Mount Helm Baptist Church is named for a white family named Helm that donated the land on the corner of what were then Grayson Street and Church Street. (Courtesy of the Smith Robertson Museum Archives and Jackson State University Archives.)

CHARLES PRICE JONES. This is a photograph of Charles Price Jones Sr. taken by African American photographer Richard Henry Beadle. Jones was a religious leader and hymnist. He was the founder of the Church of Christ (Holiness) U.S.A. Early on, Jones was a Baptist minister in Jackson, where he met Charles Harrison Mason in 1895. In 1896, Jones, Mason, and two other radical preachers held a faith-healing revival in Jackson. In 1897, Jones and Mason started their own church, first meeting in supporters' homes and eventually in a former gin house. Jones is the author of over 1,000 hymns. Some of his hymns that are still sung are *Deeper, Deeper; I Will Make the Darkness Light, Come Unto Me, Where Shall I Be?,* and *Jesus Only.* (Courtesy of Mississippi Department of Archives and History and Barbara Beadle Barber.)

CHARLES HARRISON MASON. Charles Harrison Mason was the founder of Church of God in Christ. In 1895, Bishop Mason met Charles Price Jones of Jackson; J. E. Jeter of Little Rock, Arkansas; and W. S. Pleasant of Hazlehurst, Mississippi, who subsequently became Bishop Mason's closest companions in the ministry. These gospel preachers conducted a revival in 1896 in Jackson that had major impacts on the city and the African American community. During this revival, large numbers were converted, sanctified, and healed by the power of faith. The teachings of Bishop Mason on the doctrine of sanctification caused church doors within the Baptist association to be closed to him and all that supported his teachings. In 1897, pioneering preachers came to Jackson, and Bishop Mason delivered one of his first messages from the south entrance of the courthouse in downtown Jackson. A man by the name of John Lee desired to see Bishop Mason's ministry continue and opened his home to Mason and his followers the next night. (Courtesy of Lawrence Clark.)

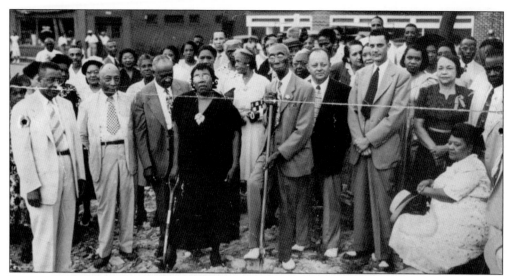

FARISH STREET BAPTIST CHURCH GROUND-BREAKING. The Reverend Elbert B. Topp served as pastor of Mount Helm Baptist Church from 1888 to 1893. Reverend Topp and 210 members of Mount Helm organized what is known today as Farish Street Baptist Church on the corner of Farish and Church Street in the heart of the Farish Street Historic District. This photograph shows the ground-breaking ceremony for the new structure spearheaded by Rev. Chester A. Greer. Lillie Bentley and Turner M. Patterson, original members who left Mount Helm Baptist Church in 1893, were on hand for the ceremony. (Courtesy of Rev. Dr. Hickman M. Johnson and Smith Robertson Museum Archives.)

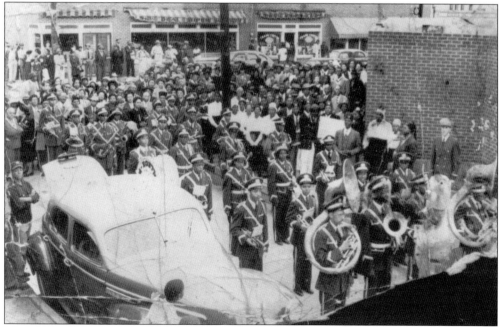

MARCHING BAND. Farish Street Baptist Church opened on the corner of Farish and Church Streets in Jackson with fanfare provided by Jackson State College. Today Jackson State University's marching band is called the "Sonic Boom of the South" and is one of the best marching bands in the Southern region. (Courtesy of Rev. Hickman Johnson and Smith Robertson Museum Archives.)

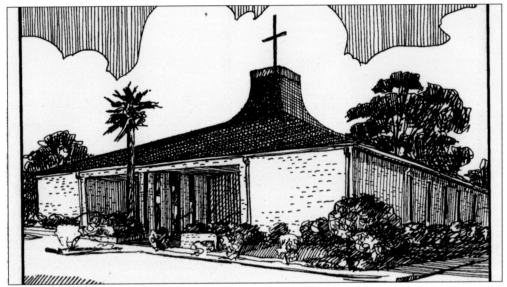

HOLY GHOST CATHOLIC CHURCH. Holy Ghost Catholic Church is the oldest African American Catholic Church in Jackson. Fr. Aloysius Heick of the Society of the Divine Word (SVD), a 41-year-old German-born priest, arrived in Jackson in 1907 to look for a suitable plot of land for a mission. Mother Katherine Drexel, the foundress of the Sisters of the Blessed Sacrament (SBS) in Philadelphia, Pennsylvania, whose sole mission was to work among the neglected African and Native Americans, gave Father Heick the necessary funds to buy the property. Holy Ghost was erected in 1909. (Courtesy of the Roman Catholic Dioceses of Jackson Archives.)

CHRIST THE KING CATHOLIC CHURCH. Christ the King parish was founded in 1945 as Jackson's third Catholic parish and the second in the city for African Americans. The roots of Christ the King parish arose from Holy Ghost parish. On October 6, 1944, Bishop Richard Gerow and Fr. Joseph Eckert, SVD, agreed to buy lot 12 on John R. Lynch Street and to split the purchase price between them. (Courtesy of the Roman Catholic Dioceses of Jackson Archives.)

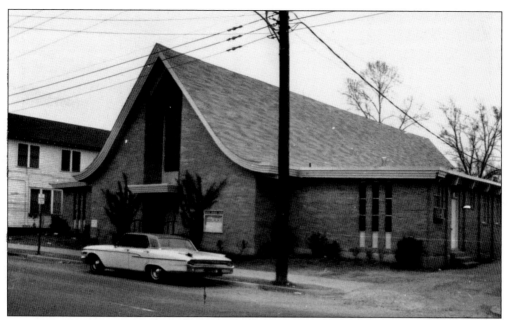

CENTRAL UNITED METHODIST CHURCH. Central United Methodist Church began in the historic Farish Street district. Central is the oldest African American United Methodist Church in Jackson. The original structure was built on land that was sold to the trustees of the church. This photograph shows the new Central Church building in the 1960s. (Courtesy of J. B. Cain Archives of Mississippi Methodism, Millsaps College.)

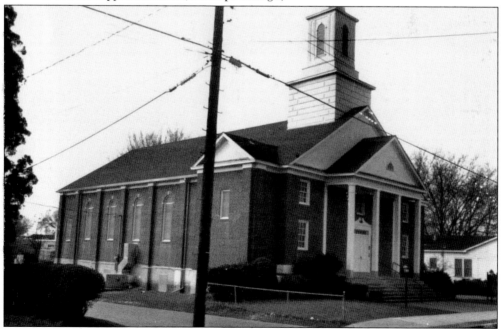

PRATT MEMORIAL UNITED METHODIST CHURCH. Pratt Memorial United Methodist Church was founded as a mission charge and organized under the ministry of Rev. Henry Henderson on July 9, 1897. Pratt Memorial is shown in the 1960s and continues to serve the West Jackson community. (Courtesy of J. B. Cain Archives of Mississippi Methodism, Millsaps College.)

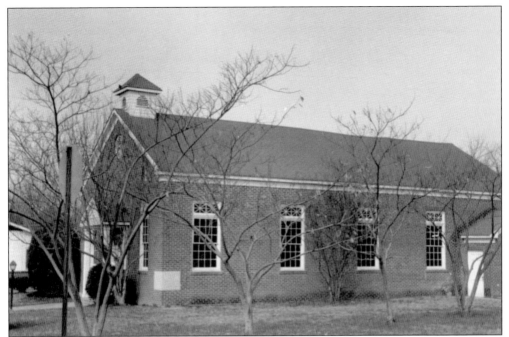

ANDERSON UNITED METHODIST CHURCH. Anderson began as a mission in 1914 under the leadership of local ministers from Central and Pratt Methodist Episcopal Churches. (Courtesy of J. B. Cain Archives of Mississippi Methodism, Millsaps College.)

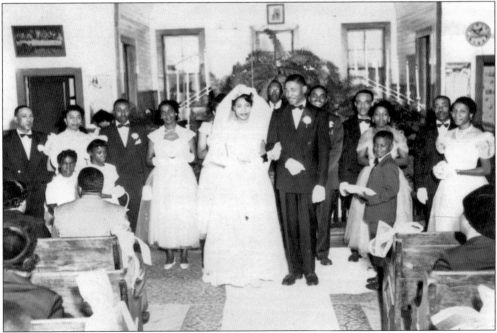

WEDDING AT FARISH STREET BAPTIST CHURCH. An African American couple's wedding party at Farish Street Baptist Church in Jackson is shown here. Many African Americans attended churches such as Farish Street Baptist, located in the Farish Street neighborhood in Jackson. (Courtesy of Mississippi Department of Archives and History.)

TWO WOMEN AND A YOUNG BOY. This photograph shows two unidentified women and a young boy standing outside of Farish Street Baptist Church in the 1960s. (Courtesy of Smith Robertson Museum Archives and Jackson State University.)

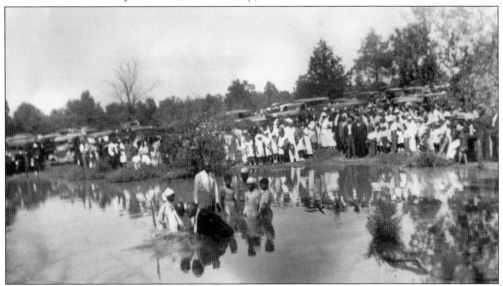

BAPTISMAL SCENE AT THE COMMUNITY OF ST. THOMAS. The St. Thomas community is located in Bolton, Mississippi, in rural Hinds County outside of Jackson. This photograph shows a baptismal service taking place in the river that runs through the community. At the beginning of the 20th century, many African Americans that were of the Baptist faith performed full-immersion baptisms in rivers, as seen in the photograph above. (Courtesy of Martha Anderson Handy.)

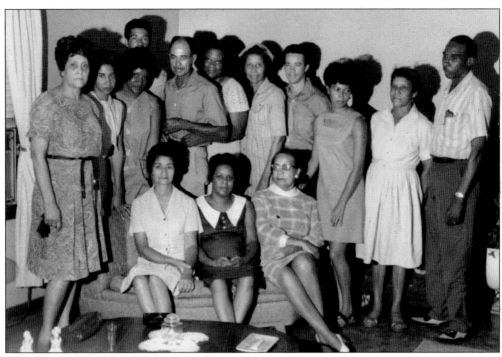

FAMILY AFTER MASS. This photograph was taken after mass at the home of the Anderson family in Jackson during the summer of 1969. Fr. Lawrence Watts of Christ the King Catholic Church officiated. Pictured from left to right are (seated) Ladelle Anderson, Geraldine Anderson, and Agnes Allen; (standing) Verna Anderson, Laura Anderson, Barbara Beadle Barber, Richard Anderson Jr., Coolidge Anderson, Wyllie Singleton, Margaret Martin, Robert Anderson, Sandra Anderson, Mrs. Howard, and Willie Martin. (Courtesy of Martha Anderson Handy.)

CARRIE BELL FORD OATIS. Carrie Bell Ford Oatis was born in Jackson, Mississippi, on April 14, 1901, to John and Virginia Ford. Oatis joined Mount Helm Church in Jackson and a was very active pianist for the Sunday school, Baptist Young Peoples Union, J. M. B. Association, and various church children's programs; she joined College Hill Baptist Church in October 1923. Oatis was the pianist at College Hill Baptist Church for 61 years and at St. James Missionary Baptist Church for 19 years. (Courtesy of Ruth O. Weir.)

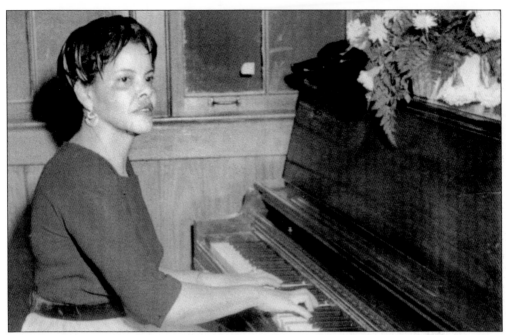

FRANCES BRITTON PLAYING THE PIANO. During Frances Britton's tenure in Jackson, between the years of 1948 and 1983, she was recognized as an accomplished musician. Britton was church organist, violinist, and choir director for 30 years at Christ the King Catholic Church. She was a sought-after musician for weddings, social events, and funerals in Jackson. (Courtesy of Tanya Britton and Camilla Britton-Lewis.)

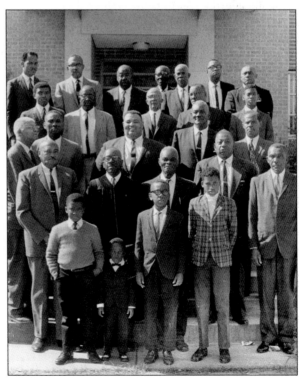

CHRIST TEMPLE (HOLINESS) CHURCH U.S.A. MEN'S DAY. This photograph shows some male members of Christ Temple Church located on Lamar Street in Jackson. Around 1960, the photograph features distinguished members of Jackson's African American community; among them are Prof. Charles H. Wilson, who is the first person pictured at left on the third row with a side profile. Professor Wilson was a well-respected educator in Jackson. Many photographs of Wilson show him pictured with a side profile. (Courtesy of Smith Robertson Museum Archives.)

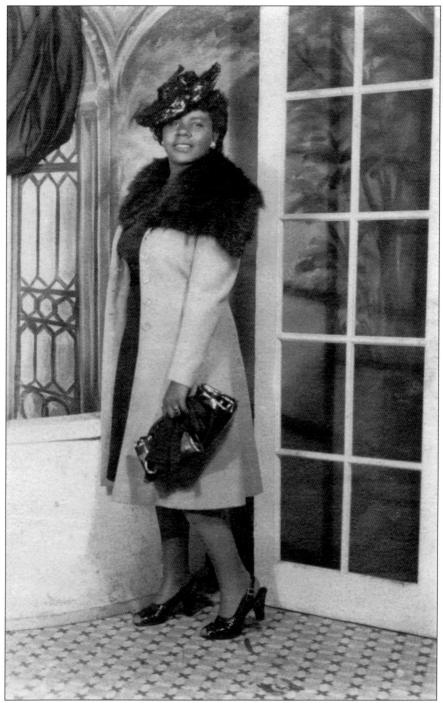

UNIDENTIFIED LADY IN SUNDAY BEST. This photograph taken by Richard H. Beadle shows an unidentified woman in her Sunday best. In the African American community, Sunday was a time that many wore their best outfits, and the women wore hats to church, which continues to be a staple in predominately African American Protestant churches in the South. (Courtesy of Smith Robertson Museum Archives.)

Two

BOOK LEARNING

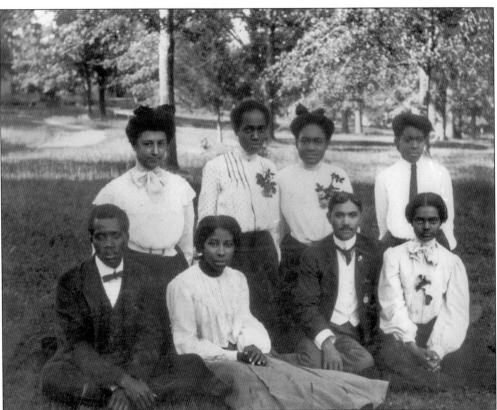

TOUGALOO COLLEGE GRADUATES. Taken on the campus of Tougaloo College c. 1900, this photograph shows early graduates of Tougaloo College near Jackson. Tougaloo was founded in 1869 by the American Missionary Association to educate the newly freed slaves. Sister institutions throughout the South include Fisk University in Nashville, Tennessee, and Talladega College in Talladega, Alabama. (Courtesy of Tougaloo College Archives.)

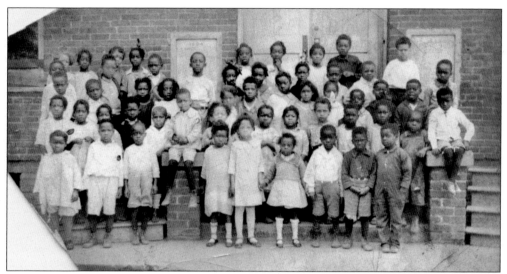

DESTROYED BY FIRE. A fire that destroyed the original structure of the Smith Robertson School takes on a phoenix-like quality in these two postcards. The borderless postcard is a full-frame real-photo postcard commemorating the new two-story brick structure built the same year as the fire in 1909. The January 3 fire, deemed arson, compounded the problem of overcrowding at Smith Robertson School. The students in the postcard represent the first class to attend Smith Robertson School after the fire and are emblematic of a hopeful future. (Courtesy of Smith Robertson Museum Archives.)

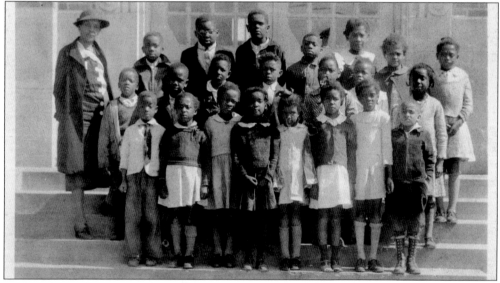

POSTCARDS. White borders were a printing practice of postcards dating from 1915 to 1930. This postcard commemorates Smith Robertson School after its 1929 art deco facade renovations. Smith Robertson School commemorated the edifice for education of the African American child with real-photo postcards. These postcards are of the divided-back style manufactured by Bazo. By selecting to memorialize both the buildings and the children for whom these structures of education stood, Smith Robertson School participated in the national craze of creating and collecting postcards, which fell out of vogue at the dawn of the development of moving pictures. (Courtesy of Smith Robertson Museum Archives.)

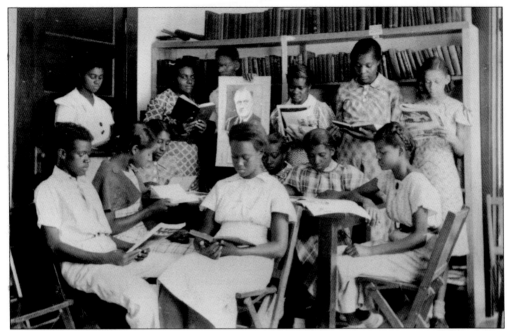

A VISIT TO THE LIBRARY. The unidentified students reading in the library are engaged in an act once deemed subversive for African Americans. Learning to read and write, once forbidden by law, has been historically the single most important self-improvement action of any African American. (Courtesy of Mississippi Department of Archives and History.)

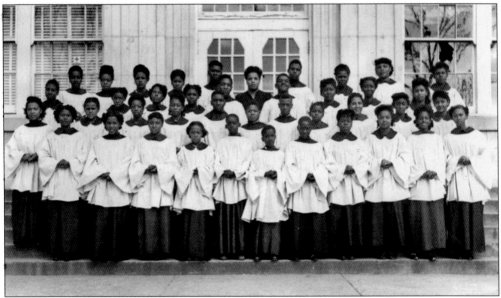

CHOIRS OF SMITH ROBERTSON SCHOOL. The student choirs of Smith Robertson School, c. 1950, pose in front of the main entrance to the school named in honor of a prominent businessperson who operated a successful barbershop. Smith Robertson was born in 1847 during slavery; he became the first African American elected as an alderman in the city of Jackson. The present building with its art deco facade was renovated in 1929 by the prominent architectural firm Hull and Mulvaney. (Courtesy of Smith Robertson Museum Archives.)

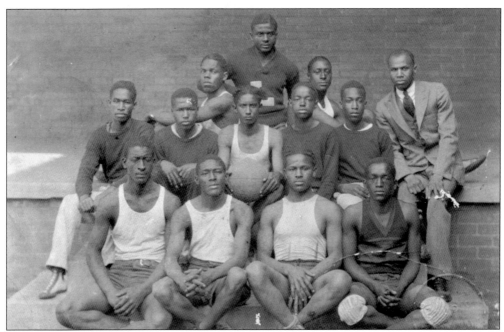

BASKETBALL TEAM. The young men of the 1929 W. H. Lanier High School Basketball team pose on the school building originally located at 139 East Ash Street in Jackson. This was the first African American high school basketball team in Mississippi. A. A. Alexander, a 1928 graduate of Jackson College, served as the team's coach. Established in 1925, Lanier High School was the first school to offer African Americans educational opportunities beyond the eighth grade. (Courtesy of Smith Robertson Museum Archives.)

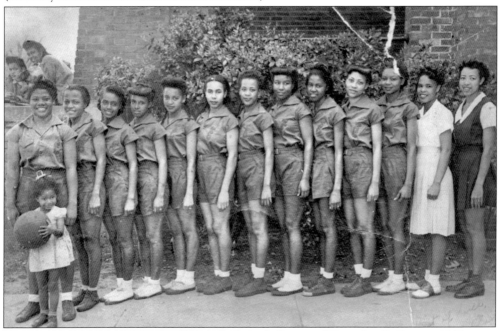

ONE EXTRA. The 13 1/2–member Women's Basketball team of Tougaloo College, *c.* 1945, poses on campus while classmates looks on. (Courtesy of Annie Bell Turner.)

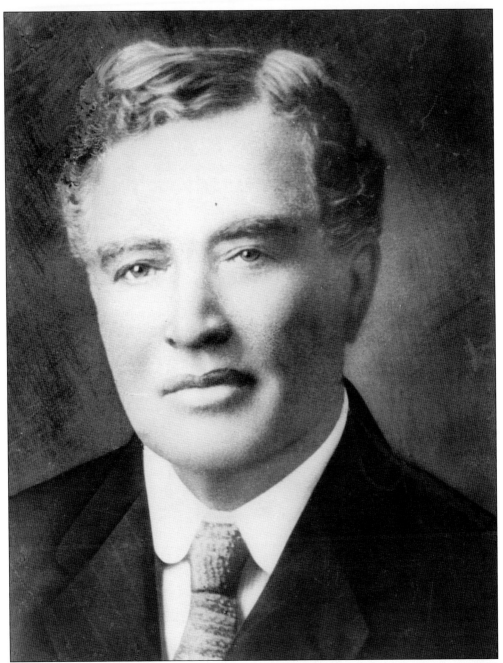

W. H. LANIER. Lanier served as both the principal for Smith Robertson School from 1912 to 1929 and as the supervisor of African American schools from 1923 to 1929. Born during slavery in 1851, William Henry Lanier attended school at Tougaloo College, Fisk University, and Oberlin College before obtaining his bachelor of arts degree from Roger Williams College. Well respected as an innovative educator, W. H. Lanier High School is named in honor of Lanier. Lanier's unexpected death in November 1929 brought to an end his 17 years of dedicated service to African American students of Jackson, Mississippi. (Courtesy of Smith Robertson Museum Archives.)

JEANES TEACHER. Florence Octavia Alexander, pictured in May 1939, was a highly respected educator. In addition to becoming the first female to be elected as president of the Mississippi Teachers Association, Alexander served as the itinerant trainer for African American schools in Mississippi and assistant supervisor of Jeanes teachers for the state, directing the teaching skills of some 6,000 African American teachers and 52 Jeanes teachers. Anna T. Jeanes, a Quaker concerned with improving education of rural African Americans, established the institution of Jeanes teachers. Selected from among the best in their college teaching classes, Jeanes teachers were mostly women and mostly African American who received pay in addition to their meager wages furnished by the local county governments. The first Jeanes teachers began in 1908, providing on-the-job training to mostly Southern, rural, African American teachers with primarily an eighth-grade education. Jeanes teachers offered standardization of the classroom material and skill sets geared toward the professionalism of teachers. The utilization of Jeanes teachers disbanded in 1968. (Courtesy of Smith Robertson Museum Archives.)

AS A YOUNG STUDENT. Internationally renowned writer Richard Wright is pictured at the top center of the R sandwiched between two unidentified female classmates. Wright graduated from Smith Robertson School in 1925 as the graduating class's valedictorian. (Courtesy of Smith Robertson Museum Archives.)

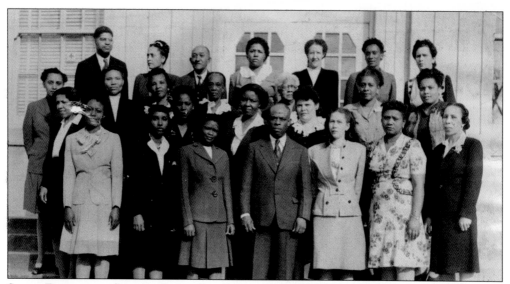

SMITH ROBERTSON SCHOOL STAFF. Standing on the front steps of Smith Robertson School are the staff under the leadership of Principal O. B. Cobbins (first row, center). Cobbins assumed the position as principal of the school immediately following the death of W. H. Lanier and served from 1929 to 1934. Like Lanier, Cobbins served concurrently as supervisor of African American schools. On the last row to the far left is Charles Wilson who is standing next to Verna Anderson. Wilson would later become the seventh principal of Smith Robertson School. (Courtesy of Smith Robertson Museum Archives.)

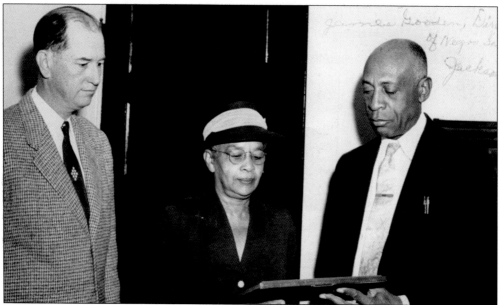

ELMETTA DAVENPORT. Davenport is receiving an award of appreciation in recognition of her unwavering service as a teacher in the African American schools of Jackson. Presenting the award is James Goodman (right) who served as the supervisor of African American schools from 1950 to 1961. Prior to becoming supervisor, James Gooden served as principal of W. H. Lanier from 1929 to 1934. Also in attendance is Dr. Kirby Walker (left), superintendent of Jackson Schools. (Courtesy of Smith Robertson Museum Archives.)

GUSTAVA GOODEN. Gus, to her friends, graduated from Jackson College in 1937. Gooden was the wife of James Gooden, who served as supervisor of the African American schools in Jackson from 1950 to 1961. Gooden taught at Smith Robertson School for the better part of her teaching career. (Courtesy of Smith Robertson Museum Archives.)

LUTHER MARSHALL. Marshall served as the fifth principal of Smith Robertson School. Marshall's tenure at Smith Robertson from 1934 to 1941 followed that of O. B. Cobbins, who took charge of the school on November 25, 1929, following the death of Principal W. H. Lanier. (Courtesy of Smith Robertson Museum Archives.)

DEDICATED SERVICE. Verna Anderson retired from teaching after 40 years of endless dedication to African American students. Anderson taught at Smith Robertson School beginning in 1936 teaching second grade and ending in May 1971, when Smith Robertson School closed. Anderson's initial second-grade class comprised students age 7 to 17. (Courtesy of Smith Robertson Museum Archives.)

ARIEL "POPS" LOVELACE. Ariel Lovelace chaired the music department at Tougaloo College. Lovelace had a great influence on many African American students at Tougaloo, encouraging them to pursue careers in music. Lovelace's daughter, Mary Lovelace O'Neal, is a celebrated visual artist. (Courtesy of the Mississippi Department of Archives and History and Barbara Beadle Barber.)

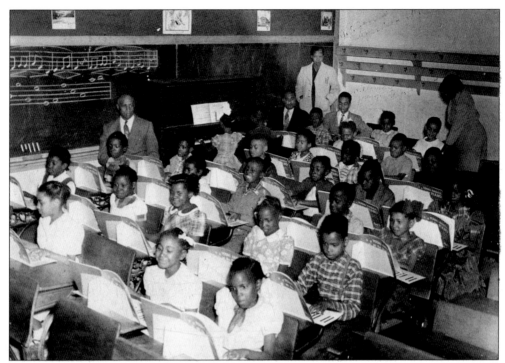

MUSIC LESSONS. Students at Smith Robertson School attend music classes, where they learn to read and play music on mock piano keyboards made of paper. (Courtesy of Smith Robertson Museum Archives.)

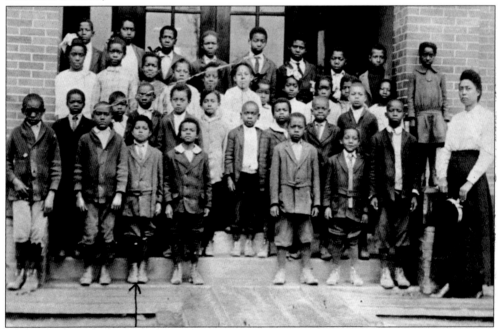

LET THE MUSIC BEGIN. Dr. Kermit Holly (over the arrow) is shown as a young student in 1914 at the Jim Hill School. Holly would continue his educational training in music at Chicago Musical College and Richmond Professional School of Music. (Courtesy of the Holly Foundation.)

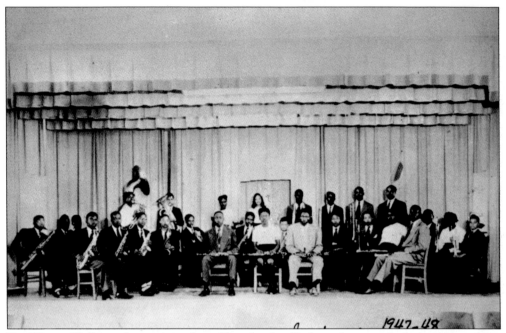

DR. HOLLY. Holly taught music in the public schools of Jackson; however, he began his teaching career at Clark College in Atlanta, returning to Jackson in 1930. Holly taught at Jackson and Alcorn Colleges. Dr. Holly is pictured with his students at Jackson College in 1947. (Courtesy of the Holly Foundation.)

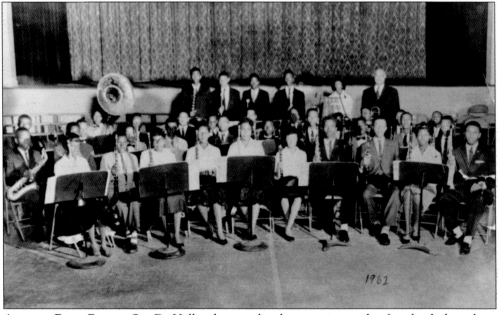

AND THE BAND PLAYED ON. Dr. Holly, who served as the extension teacher for schools throughout the state of Mississippi, is pictured with his 1962 W. H. Lanier High School Band, which was renowned for its instrumentation. Holly was himself a very accomplished musician, rounding out his career in music education as a concert violinist, singer, pianist, arranger, and band and choral director. (Courtesy of the Holly Foundation.)

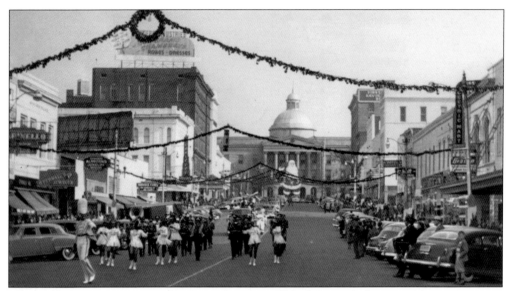

MARCHING BAND ON CAPITOL STREET IN JACKSON. This photograph shows an African American marching band parading down Capitol Street in downtown Jackson. Capitol Street in Jackson was home to many hotels, department stores, and restaurants and was the shopping district for white patrons in Jackson. Farish Street, located off Capitol Street, was the shopping and entertainment district for African Americans in Jackson. The Jackson State Marching Band were one of the first African American marching bands to parade on Capitol Street; they appeared under the direction of Dr. Holly. (Courtesy of the Mississippi Department of Archives and History.)

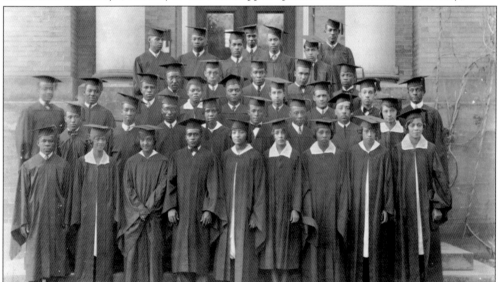

CAMPBELL COLLEGE. The unidentified graduates featured are believed to be graduates of Campbell College. The college was founded around 1890 as a religious institution governed by the African Methodist Episcopal Church. Founded outside of Jackson, the college nonetheless became an educational landmark in the city, with remnants of its former self located on the campus of Jackson State University's Green Hall. Campbell College served as an independent location during the civil rights era, as did Tougaloo College. Both campuses offered safe space to gather, organize, and strategize movement activities. (Courtesy of Smith Robertson Museum Archives.)

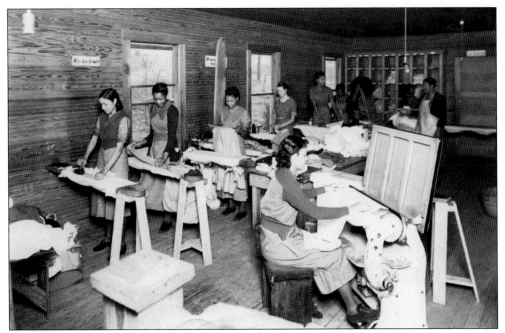

Piney Woods Country Life School. The school founded by Laurence Jones began on a 40-acre plot of land in Rankin County, Mississippi. The coeducational school offered domestic training for young women, such as those seen here ironing with hot iron presses as well as larger industrial roll-press machines seen in the forefront. (Courtesy of Smith Robertson Museum Archives.)

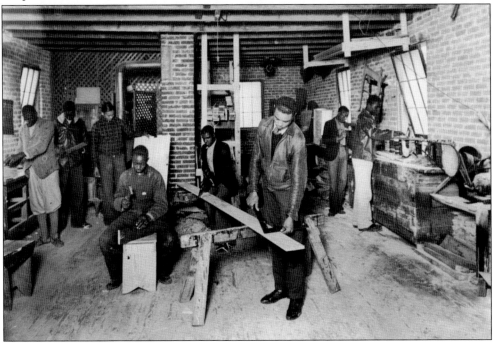

Woodwork in the Woodshop. Young men pictured in the carpentry shop learn by doing as they put their skills to use to pay off tuition and support operations at the school. (Courtesy of Smith Robertson Museum Archives.)

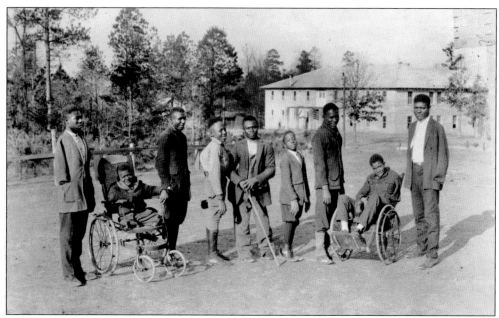

NO DIFFERENCE. Differences in the ability to perform were not deterrents to education and learning practical skills, as evident in this image of young male students of the Piney Woods Country Life School. Note that these young men represent an array of physical limitations, but more importantly, they represent capabilities that are mutually supportive of one another as well as their community. (Courtesy of Smith Robertson Museum Archives.)

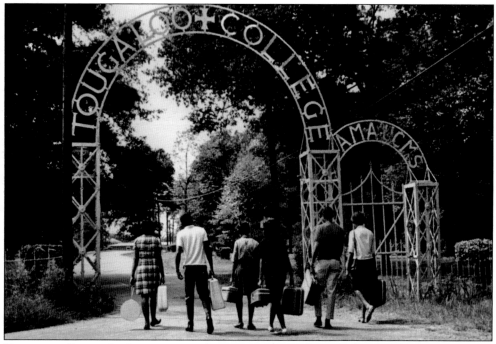

TOUGALOO GATES. Students carrying their suitcases enter through the wrought iron gate at the entrance of Tougaloo College. Many students may walked a mile or more from the main road to enter the campus grounds. (Courtesy of Tougaloo College Archives.)

Three

HAVING THEIR SAY

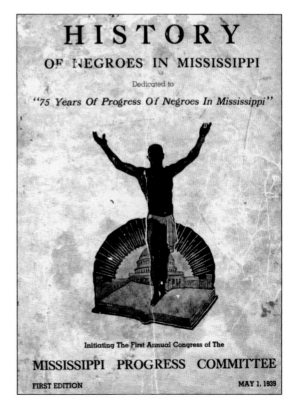

HISTORY OF NEGROES IN MISSISSIPPI: 75 YEARS OF PROGRESS BOOKLET COVER. Published in 1939, the *History of Negroes in Mississippi: 75 Years of Progress* chronicles the contributions and achievements of African Americans in the state. The purpose was to give the nation a progress report of African Americans in Mississippi 75 years after the signing of the Emancipation Proclamation. (Courtesy of Smith Robertson Museum Archives.)

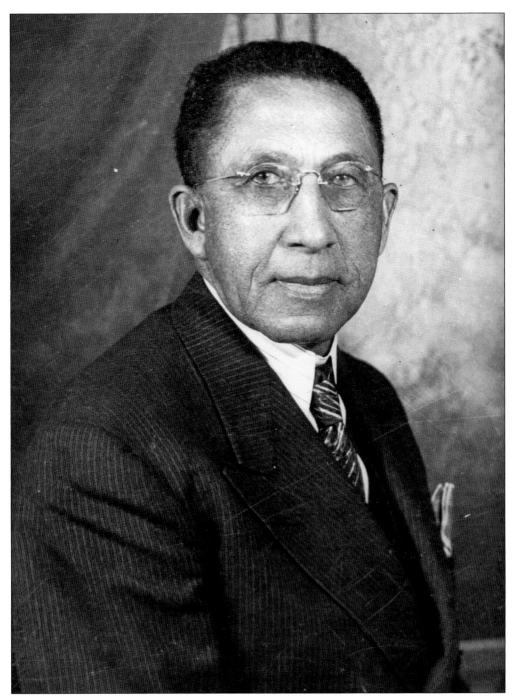

S. D. REDMOND, M.D. Dr. Sidney Redmond's career dates back to the days of Reconstruction. He was perhaps the first African American millionaire in the state of Mississippi. At one time, Redmond owned more than 200 houses in Jackson, and two streets in the city of Jackson still bear his name. Redmond was president of American Trust and stockholder in three banks controlled by whites. (Courtesy of the Mississippi Department of Archives and History, Smith Robertson Museum Archives, and Barbara Beadle Barber.)

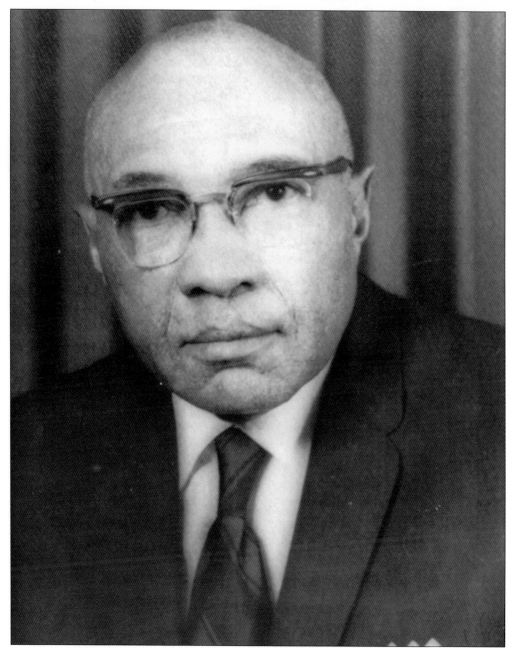

A. H. McCoy, D.D.S. Dr. A. H. McCoy was a dentist and business leader in Jackson. Dr. McCoy was born in Jackson and educated at Tougaloo College in Jackson and Meharry Medical College in Nashville, Tennessee. Dr. McCoy's contributions to the African American community were so impressive that 12 years after his death in 1970, a group of African American community leaders got together to propose naming the federal building in downtown Jackson after Dr. McCoy. This would be the first federal building in the country named in honor of an African American. This photograph was taken by African American photographer Richard H. Beadle in Jackson. (Mississippi Department of Archives and History, Smith Robertson Museum Archives, and Barbara Beadle Barber.)

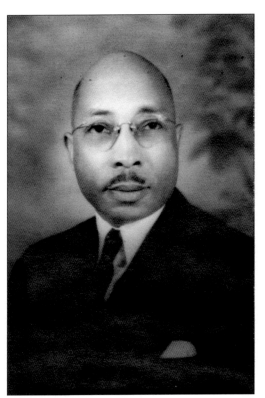

C. L. BARNES, D.D.S. Dr. Barnes was a dentist who served the African American community in Jackson. Dr. Barnes's office was located on Farish Street in Jackson, where he practiced dentistry for 23 years. Dr. Barnes was born in D'Lo, Mississippi, graduated from Alcorn State College (now Alcorn State University), and did postgraduate work at Northwestern University and the University of West Tennessee. (Courtesy of Smith Robertson Museum Archives and Barbara Beadle Barber.)

C. B. CHRISTIAN, M.D. Dr. Christian practiced medicine in Jackson and served as superintendent of the Fraternal Hospital in there. Dr. Christian was born in Madison, Mississippi, just north of Jackson. This photograph of Dr. Christian was taken by African American photographer Richard H. Beadle. (Courtesy of Smith Robertson Museum Archives and Barbara Beadle Barber.)

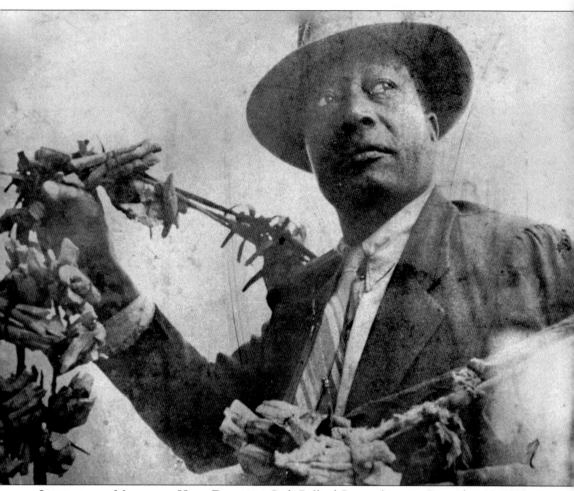

LAST OF THE MISSISSIPPI HERB DOCTORS. Seth Ballard Sr. was born on December 10, 1897. Ballard's peculiar occupation caught the attention of a 103-year-old former slave, whose name is unknown, who mentored Ballard. The lessons he taught, which were improved upon by Seth Ballard, leave us with a complete picture as to the nature and practicalities of Ballard's profession as an herb doctor. Ballard is shown with sassafras roots around his neck. (Courtesy of Smith Robertson Museum Archives.)

MATTIE RUNDLES, R.N. Mattie Rundles was one of the distinguished few chosen to integrate Jackson's Veterans Memorial Hospital in 1949. She was cofounder of the Eliza Pillars Nurse Association; she was also the first African American nurse to receive the Outstanding Mississippian Award and *Ebony* and *Jet Magazine* Award from the American Red Cross for her devoted efforts during Hurricane Camille, which struck the Mississippi Gulf Coast in 1969. (Courtesy of Smith Robertson Museum Archives.)

WILLIAM E. MILLER II, M.D. Near the beginning of the 20th century, William Edward Miller was born to Samuel Albert Miller Sr. and Lucille F. Weathers Miller, both of whom were physicians and resided in the Historic Farish Street District of Jackson. The family lived on 138 North Farish Street. Notably Dr. Lucille Miller was the first female to practice medicine in the state of Mississippi; she graduated from Meharry Medical School in Nashville, Tennessee, in 1900. Her son, Dr. William E. Miller, graduated from Harvard University in Cambridge, Massachusetts, with a master's degree in public health in 1932, and he was the only African American in his class. In that same year, Dr. Miller taught bacteriology and preventive medicine at Meharry in Nashville. Pres. Jacob L. Reddix appointed Dr. Miller medical director of the Zachary Taylor Hubert Health Center and college physician, where he remained until he entered private practice in 1952. (Courtesy of Smith Robertson Museum Archives.)

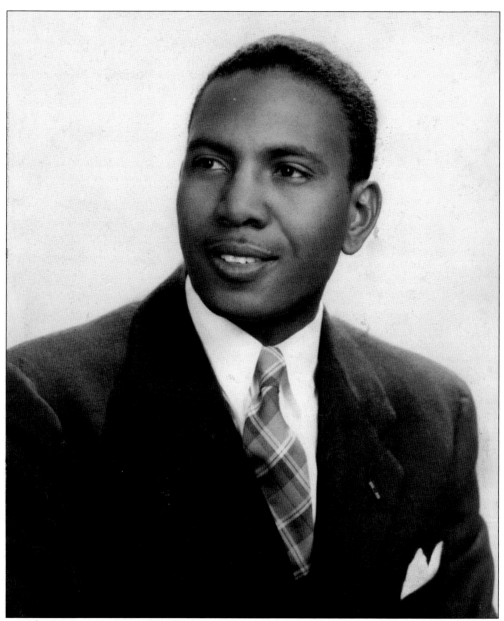

ALBERT B. BRITTON JR., M.D. Dr. Britton was born on January 17, 1922, in Enterprise, Clarke County, Mississippi. He attended elementary school in Bay Springs and Shubuta, Mississippi. Dr. Britton graduated valedictorian from his high school class at Lanier High School in Jackson in 1940. He pursued his undergraduate studies at Tougaloo College and graduated in 1943. In 1947, Dr. Britton received his medical degree from Howard University College of Medicine in Washington, D.C., and in 1948, he returned to Jackson and practiced medicine as a general practitioner with obstetrics and gynecology as subspecialties. Between the years of 1951 and 1953, Dr. Britton served as an army physician, specifically as assistant division surgeon at Fort Riley, Kansas; he also served in combat overseas during the Korean War as battalion surgeon, acting division surgeon, and medical director of a military Korean medical hospital. (Courtesy of Albert B. Britton, Jr., M.D., Camilla Britton-Lewis, and Tanya Britton.)

PERCY GREEN. In 1927, Percy Green started the *Colored Veteran*, a publication of the National Association of Negro War Veterans at a time when African Americans could not join the American Legion or Veterans of Foreign Wars. This tabloid eventually became the *Jackson Advocate* in 1938. Today the *Jackson Advocate* is still publishing from its office in the Historic Farish Street District as the state's largest African American newspaper. This photograph was taken by African American photographer Richard Henry Beadle in Jackson. (Courtesy of Mississippi Department of Archives and History and Barbara Beadle Barber.)

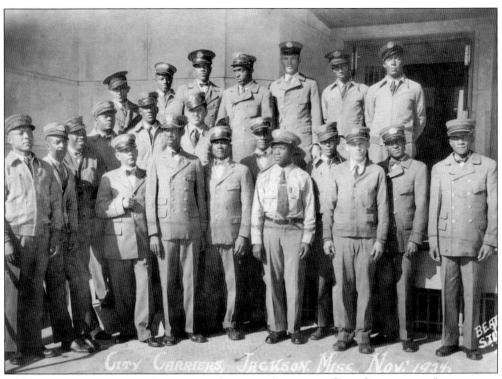

AFRICAN AMERICAN CITY CARRIERS IN JACKSON. This photograph captures 20 African American mail carriers in Jackson in November 1934. The photograph was taken on the loading dock behind the U.S. Post Office in downtown Jackson on Capitol Street. These mail carriers served the African American communities of Jackson. Eleven of the 22 men are identified as follows: (first row) R. L. T. Smith (left), James A. Stewart Sr. (fourth from the left), B. P. Newman (fifth from the left), Abe Elmore (sixth from the left), Contella Griffin (seventh from the left), and Earnest Slaughter (eighth from the left); (second row, fourth from the left) John W. Dixon; (third row) Alton B. Moman (left), Thomas Carl Almore Sr. (second from left), James White (fourth from the left), and Carsie Hall (right). (Courtesy of Smith Robertson Museum Archives.)

ATTORNEY CARSIE HALL. Attorneys Carsie Hall, R. Jess Brown, and Jack Young Sr. were the only African American lawyers who were licensed to practice in the state of Mississippi in the early 1960s. Attorney Hall was a letter carrier in Jackson and subsequently went on to become a very prominent civil rights attorney in Jackson. (Courtesy of the Mississippi Department of Archives and History and Barbara Beadle Barber.)

ATTORNEY JACK H. YOUNG SR. Attorney Jack Young Sr. was born in Jackson on March 9, 1908. Young attended St. Mark's Episcopal Church kindergarten. He attended Jim Hill Public School. Young completed seventh grade at Jim Hill and then transferred to Smith Robertson School, which went to the ninth grade. He graduated valedictorian of his high school class, and in 1923, he continued his education at Jackson State College, where he was a member of the debating team and the college symphony orchestra. Young finished college at Jackson State, graduating at the top of his class. Jack Young Sr. wanted to attend law school after college. Young and fellow letter carrier Carsie Hall asked Sidney R. Redmond, a graduate of Harvard Law School, to tutor them. Young passed the Mississippi bar on September 25, 1951. Young became one of the three African American attorneys representing civil rights activists in the 1960s. Attorney Young's home that he shard with his wife, Aurelia, is located at 627 Pearl Street and was a meeting place for many activists from all across the country. (Courtesy of Smith Robertson Museum Archives.)

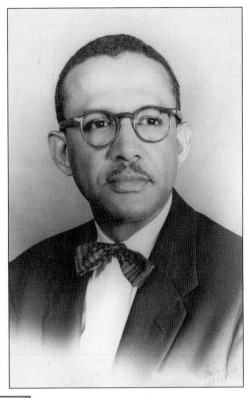

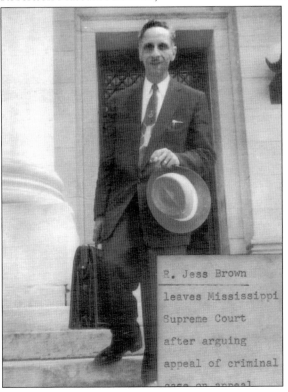

R. Jess Brown leaves Mississippi Supreme Court after arguing appeal of criminal

ATTORNEY RICHARD JESS BROWN. Attorney Brown was born in Coffeeville, Kansas, in 1912. He relocated to Mississippi around 1946 and settled in Jackson by 1948. Brown taught at Prairie View College in Texas and at Alcorn State. R. Jess Brown was a plaintiff in the first civil rights case in Mississippi along with Gladys Noel Bates. They sued on behalf of African American teachers to have their salary be equal to that of their white colleagues. Brown eventually became an attorney, arguing cases before the Mississippi Supreme Court on behalf of James Meredith's right to attend the University of Mississippi. (Courtesy of attorney Melvin Cooper and Maxine Jackson.)

43

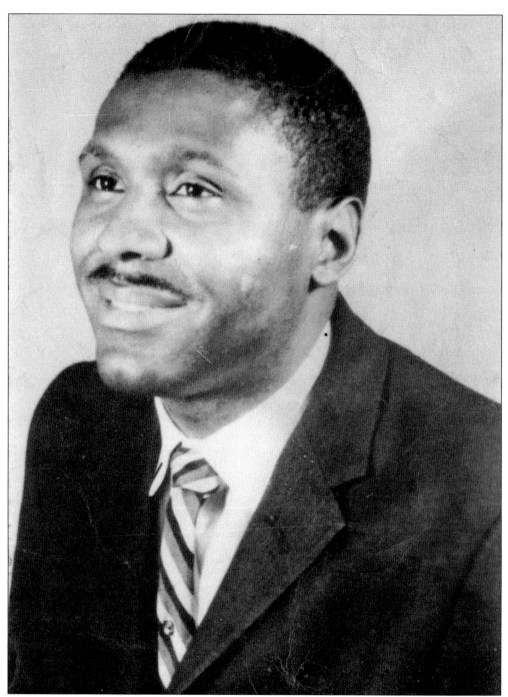

HON. ROBERT G. CLARK. In 1967, Robert G. Clark was elected to the Mississippi State Legislature. He was the first African American to serve in the Mississippi Legislature since 1894, when G. W. Gayles of Bolivar County, Mississippi, and G. W. Butler of Sharkey County, Mississippi, completed their terms. His most memorable position is that of chairman of the Education Committee, where he helped pass the Mississippi Education Reform Bill of 1982. (Courtesy of Smith Robertson Museum Archives.)

HON. HENRY J. KIRKSEY. Sen. Henry Kirksey was a Mississippi state senator and a tireless proponent of civil rights. He was the lead plaintiff in most of the redistricting cases brought forward in Mississippi in the late 1960s and early 1970s to bring the state into compliance with the 1965 Voting Rights Act. As a result of Kirksey's work, Mississippi today has many more African American elected and appointed officials than was formerly the case. Kirksey became the first African American elected to the Mississippi Senate since Reconstruction. (Courtesy of Smith Robertson Museum Archives.)

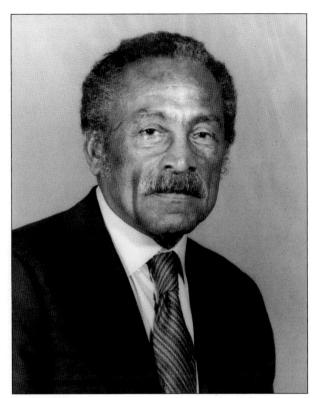

FRED L. BANKS JR., ESQ. Fred Banks Jr., a native of Jackson, is a graduate of Howard University, where he earned his bachelor of arts degree and jurist doctorate. Banks has been affiliated with the National Conference of Black Lawyers, the Urban League, the National Association for the Advancement of Colored People (NAACP), and the National Association of Teachers of Attorneys. Banks was elected to the Mississippi House of Representatives in 1974; attorney Banks represented the 69th District. (Courtesy of Smith Robertson Museum Archives.)

ATTORNEY REUBEN V. ANDERSON.
Attorney Reuben V. Anderson is
pictured on the right-hand side of
this photograph taken on Tougaloo
College's campus. On January 11,
1985, Reuben Anderson became
the first African American judge
to be appointed to the Mississippi
Supreme Court. Anderson, a native
of Jackson, received his bachelor of
arts degree from Tougaloo College
in 1964 and his juris doctorate
degree from the University of
Mississippi in 1967. He served as
a municipal judge from 1975 to
1977 and as circuit judge of the 7th
Circuit Court, State of Mississippi
from 1982 to 1985. Anderson served
on the Mississippi Supreme Court
from 1985 to 1990 and later served
as president of the Mississippi Bar
Association from 1997 to 1998.
(Courtesy of Tougaloo College
Archives and Attorney Reuben
V. Anderson.)

**THE FIRST AFRICAN AMERICAN MAYOR OF
JACKSON.** The Honorable Harvey Johnson
Jr. was born in Vicksburg, Mississippi. He was
educated in the Vicksburg Public Schools,
where he graduated from Temple High School.
Johnson received his bachelor of arts degree
from Tennessee State University in Nashville,
Tennessee, and his master of arts degree from
the University of Cincinnati in Cincinnati,
Ohio. Johnson was elected mayor of Jackson
in June 1997. This election was significant
because Johnson would be the first African
American elected as mayor of Mississippi's
capital city. (Courtesy of the Honorable Harvey
Johnson Jr.)

MASONIC PHOTOGRAPH. This photograph shows members of the M. W. Stringer Grand Lodge in Jackson. The Most Worshipful Stringer Grand Lodge was established in 1873 when Thomas W. Stringer petitioned and received a charter. The first Grand Lodge session was held in Vicksburg, Mississippi, in 1875. (Courtesy of Smith Robertson Museum Archives.)

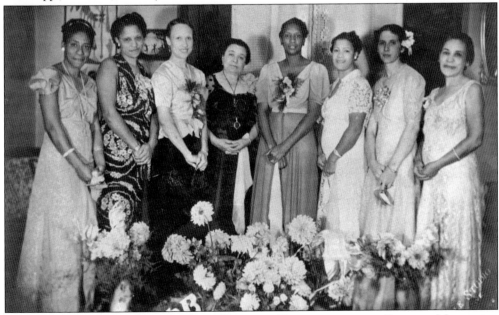

THE FIRST CHAPTER OF ZETA PHI BETA SORORITY CHARTERED IN THE STATE OF MISSISSIPPI, 1938. Zeta Phi Beta, Inc., was founded on January 16, 1920, on the campus of Howard University in Washington, D.C. Pictured from left to right are Julia Clark, Estelle G. Young, Lullelia M. Harrison, Jennil Johnson, Mollie Young, Mable Rosmond, Berdia Graves, and Helen Allen Cooper. This is a Beadle Studio photograph. (Courtesy of Smith Robertson Museum Archives.)

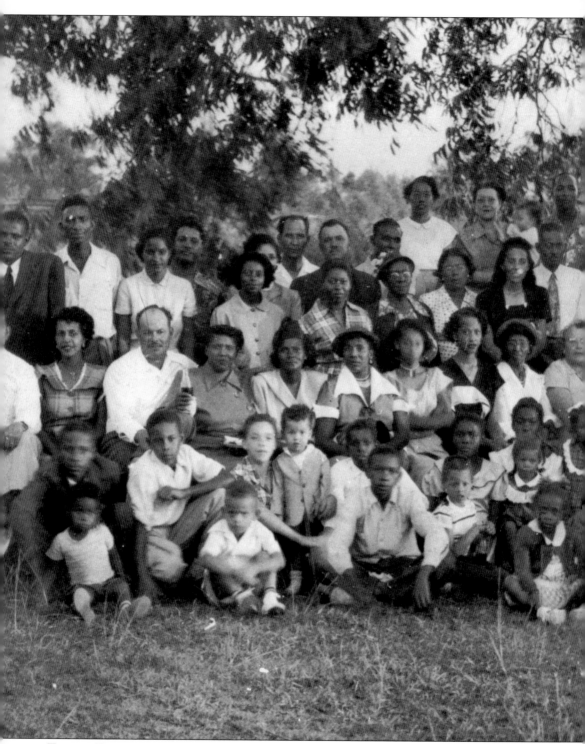

Thomas Family Reunion. The Thomas family reunion has been going strong for over 65 years and continues to this day. The reunion takes place every year in the St. Thomas community of Bolton, Mississippi, outside of Jackson. Richard H. Beadle of Jackson took this photograph; note

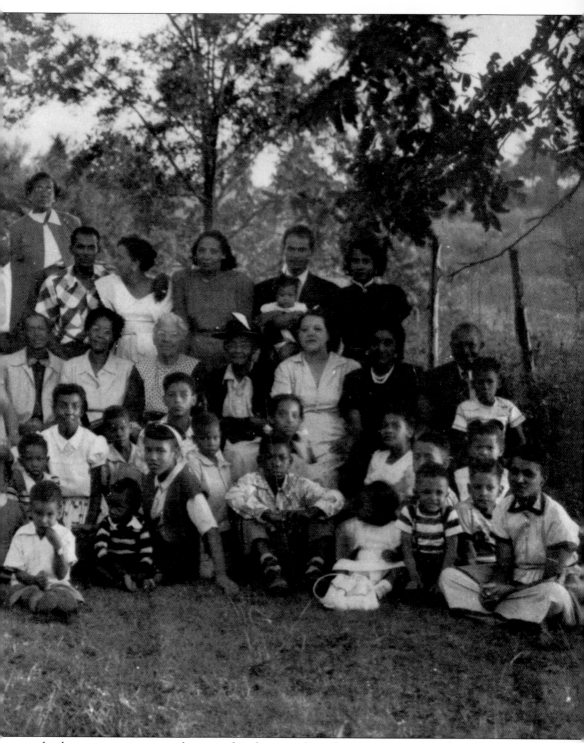

his box camera sitting on the ground in front on the right side of the photograph. (Courtesy of Smith Robertson Museum Archives.)

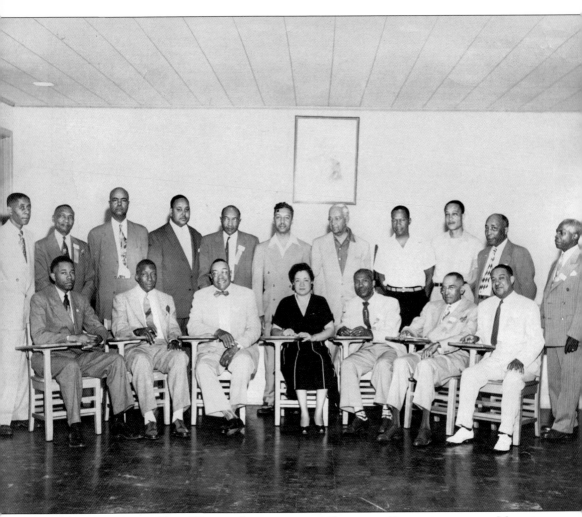

PORTRAIT OF LILLIE BELL WALKER JONES AND THE BOARD OF DIRECTORS OF THE MARINO BRANCH OF THE YWCA. This photograph shows the board of directors and Lillie Bell Walker Jones, director of the YWCA Marino Branch located on Farish Street in Jackson. Jones served as the director from 1945 to 1982. The Young Woman's Christian Association (YWCA) was founded 150 years ago in New York City. Prior to the civil rights movement in the 1950s and 1960s, most YWCAs were segregated, like the Marino Branch YWCA. In Washington, D.C., an advocate by the name of Helen L. Seaborg worked to mediate mergers between the segregated YWCA branches. Today the YWCA works tirelessly to eliminate racism and empower women worldwide. (Courtesy of Smith Robertson Museum Archives.)

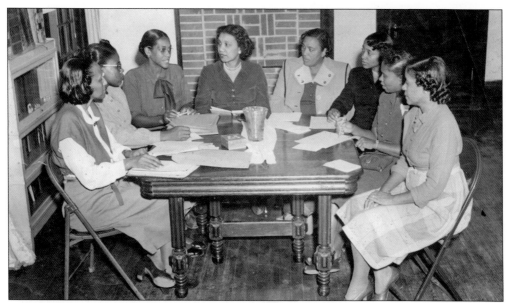

WOMEN PLANNING PROGRAMS AT THE YWCA MARINO BRANCH. This photograph shows women planning programs at the YWCA Marino Branch on Farish Street. Programs such as Early Service Learning Center, Family Resource Center, Out-Of-School Programs, and Woman's Employment are among the services offered at YWCAs nationwide. This photograph was taken by African American photographer Richard Henry Beadle in Jackson. (Courtesy of Smith Robertson Museum Archives.)

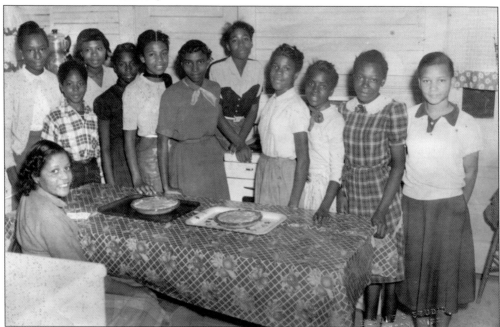

BAKE SALE AT THE YWCA MARINO BRANCH ON FARISH STREET. This Beadle Studio photograph (Richard H. Beadle, photographer) shows young girls and sponsor Anita Beadle Scott (seated) showing off pies for a bake sale to possibly be held as a fund-raiser for the YWCA Marino Branch on Farish Street in Jackson. (Courtesy of Smith Robertson Museum Archives.)

MINNIE FARISH. Farish is a descendant of the late Walter Farish, for whom Farish Street is named. Minnie attended Smith Robertson School. The following quote is excerpted from the 1982 Farish Street Humanities Oral History Project: "I graduated from Smith Robertson School in 1925, from the 8th grade. . . . I began school the fall of the year in 1914, a few months before my fifth birthday in December. . . . Mrs. Mary Jones was my teacher. A slate, tablet, pencil eraser and chalk were the tools I used in class. . . . Being to school on time meant getting a chance to do calisthenics, then marching." (Courtesy of Tanya Britton.)

MR. AND MRS. KERMIT W. HOLLY. Kermit Holly married Lavonia Avery Holly in 1946. They shared a joyous marriage and parented three sons and one daughter. Dr. Holly retired in 1973, having served as an educator of musicology for 46 years. Mrs. Holly survived her husband and is now retired after 30 years of service to the medical profession. Mrs. Holly, born in 1921 in Kosciusko, Mississippi, worked as a registered nurse throughout her career. (Courtesy of the Holly Foundation.)

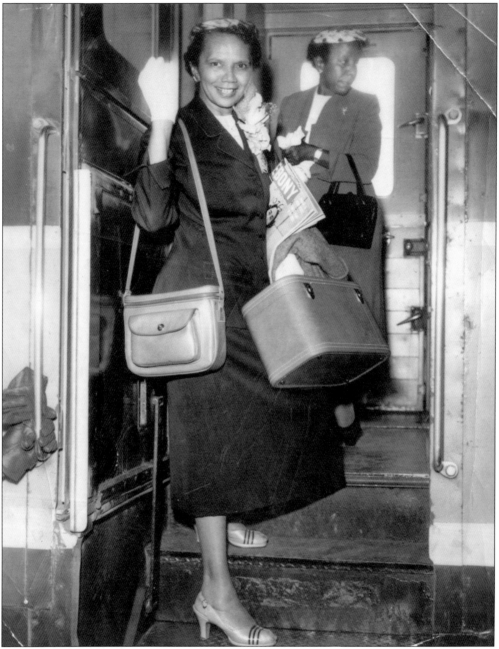

AFRICAN AMERICAN WOMAN BOARDING A TRAIN. This photograph shows a woman waving goodbye and boarding a train. Note the *Ebony* magazine in her hand for reading while she journeys to her destination. *Ebony* was founded in 1945 by publisher John H. Johnson in Chicago. The magazine features articles that pertain to African American issues and personalities. (Courtesy of Smith Robertson Museum Archives.)

Four

MORE THAN JUST GETTING BY

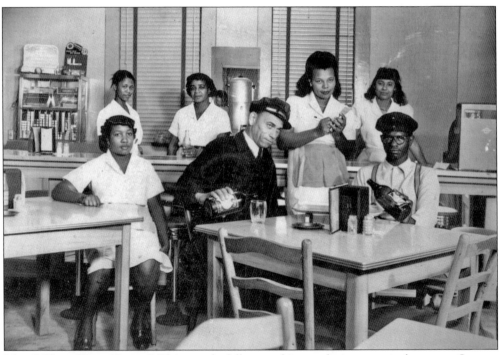

MAY I TAKE YOUR ORDER? This wonderfully staged image depicts a typical scene at Stevens Kitchen around 1940. The local lunch spot offered authentic Southern cuisine to the African American community. During the civil rights era, Stevens served home-style cooking to such notables as Dr. Martin Luther King Jr. and Sen. Robert Kennedy. (Courtesy of Smith Robertson Museum Archives.)

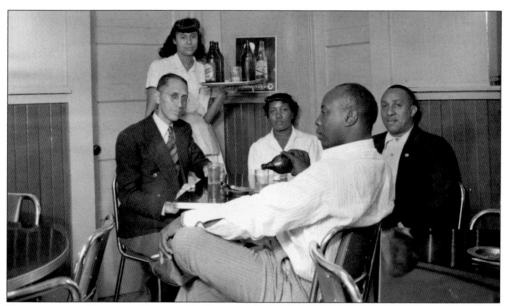

POSE FOR THE CAMERA. Stevens Kitchen was located at 604 North Farish Street, the hub of African American entrepreneurship. Folklore has it that Farish Street is named in honor of one of the community's founding leaders, Walter Farish, a former slave. The Illinois Central Railway, King Edward Hotel, and the Greyhound bus station were in walking distance of Stevens Kitchen. Each of these Jackson landmarks provided employment to African Americans. (Courtesy of Smith Robertson Museum Archives.)

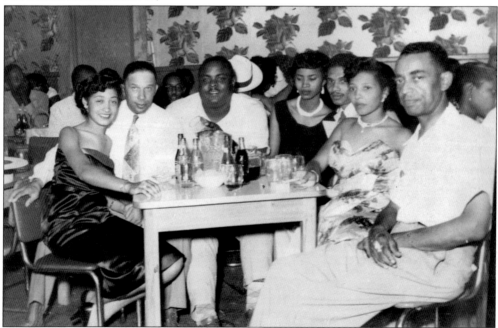

ALL HAD A GOOD TIME. Stevens Lounge, owned by the same enterprising owners as Stevens Kitchen, provided the African American community with late-night entertainment by local and itinerant talent. Located on Sunset Drive, Stevens Lounge, modernly decorated, advertised a drawing feature—air conditioning. (Courtesy of Smith Robertson Museum Archives.)

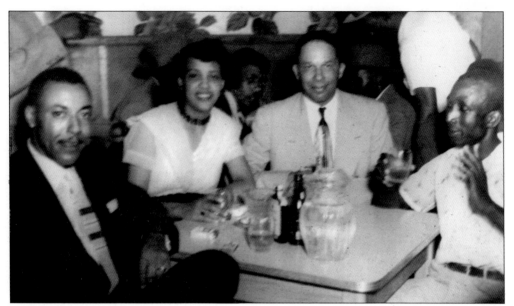

STEVENS LOUNGE. Comparing this image to the one on page 56, one is able to see that the couple seated at the far left end of the table is the same couple appearing in the center of the image. Note too that their table guest, seated second from the right in the image on page 56, is the same person at the far left end of the table in this image. The pictures clearly depict late-night enjoyment but were obviously not taken on the same evening. (Courtesy of Smith Robertson Museum Archives.)

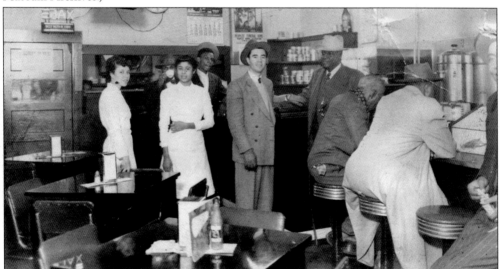

SHEPHERD'S KITCHENETTE. David Shepherd established Shepherd's Kitchenette originally above the Crystal Palace on Farish Street. Shepherd, considered one of the best cooks in Jackson, prior to opening his own business was employed at the popular Jackson restaurant Pantaise located on Capitol Street. Shepherd's was known for its famous oyster loaf, a Jackson version of a New Orleans po' boy. Legend has it that Shepherd's oyster loaf was just as tasty, if not more so, than Hodges Grocery's sardine loaf. Patrons of both Hodges Grocery and Shepherd's Kitchenette purchased their delicious sandwiches for just 15¢. This image is of Shepherd's around 1947. (Courtesy of Smith Robertson Museum Archives.)

THERE IS ALWAYS ROOM AT THE BIG APPLE INN. The Big Apple Inn is still operating today, with the original one still located on Farish Street and the newer establishment located on State Street. Gene Lee Sr. began the business back in the early 1930s by selling hot tamales from a tin bucket on street corners. Known for their Southern delicacies of pig ear sandwiches, Gene Lee Sr., Harold Lee, and Gene Lee Jr. are still serving the Jackson community. This image depicts unidentified customers waiting to receive their carry-out orders while others pose for the photographer. (Courtesy of Smith Robertson Museum Archives.)

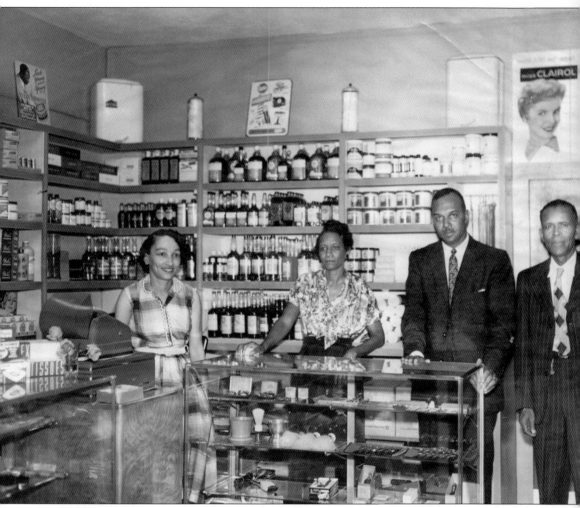

WE SUPPLY ALL OF YOUR HAIR NEEDS. Conic's Beauty and Barber Supply was one of the first African American suppliers to retail Clairol products to the African American consumer. Conic's also began distributing Ultra Sheen, a product produced by Johnson Products. Frank Conic was the son of John Edgar Conic who, along with Albert Shaw, owned and operated City Barber Shop complete with seven chairs and two bathtubs. Conic Beauty and Barber Supply operated from 1950 to 1975 at 615 North Farish Street. From left to right are Doris V. Conic, Myrtle C. Johnson, Frank N. Conic, and Jack Johnson. Prior to Frank Conic opening his beauty supply business, R. J. Garrett ran a beauty supply store named Garrett Products, also on Farish Street, that not only sold beauty supplies but also manufactured beauty products. (Courtesy of Smith Robertson Museum Archives.)

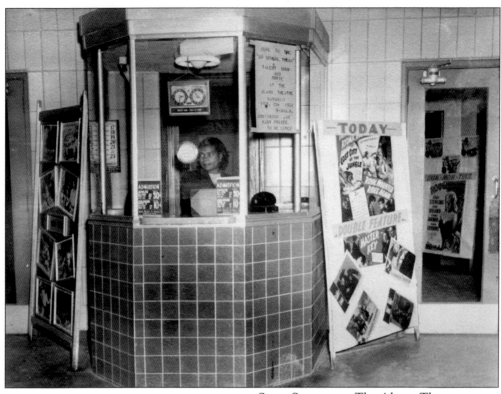

STILL STANDING. The Alamo Theater offered African American moviegoers an opportunity to see a movie in a theater that did not relegate them to the rooster coup of the theater's balcony. For as little as a dime, children and adults enjoyed films featuring African American actors and the national showings of chase westerns. The Alamo underwent renovations in the last decade and now offers performing arts entertainment. (Courtesy of Smith Robertson Museum Archives.)

W. A. SCOTT BUILDING. Located at 705 North Farish Street, William A. Scott, pastor of Farish Street Christian Church at 918 North Farish Street, constructed the building to house the Progressive Printing Company. Scott moved to Atlanta, Georgia, and established the first African American newspaper, the *Atlanta Daily World*. (Courtesy of Roland L. Freeman and Smith Robertson Museum Archives.)

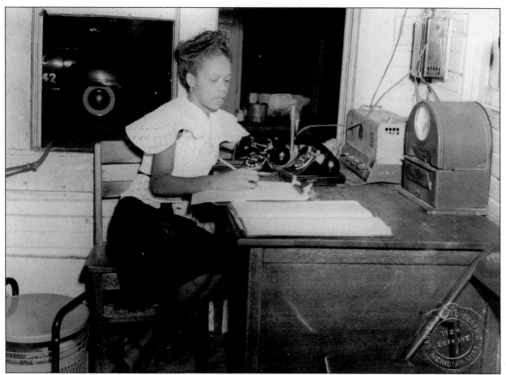

DISPATCH CENTRAL AT DOTTY CAB COMPANY. An unidentified female employee of Dotty Cab logs in calls for service. (Courtesy of Smith Robertson Museum Archives.)

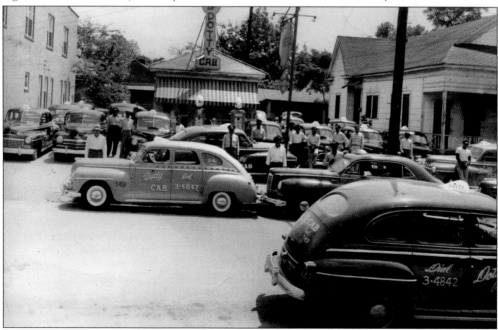

AT YOUR SERVICE. Dotty Cab headquartered on Farish Street closed down operations nearly two decades ago. At the time of this image, c. 1940, Dotty ran a fleet of over two dozen cabs servicing African Americans of Jackson. (Courtesy of Smith Robertson Museum Archives.)

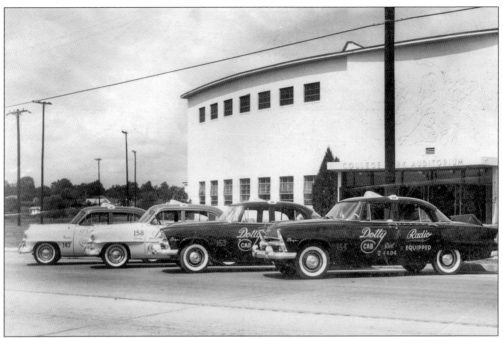

YOU RANG? Dotty Cab in the 1940s awaits the opportunity to provide transportation to students of Jackson State University. (Courtesy of Smith Robertson Museum Archives.)

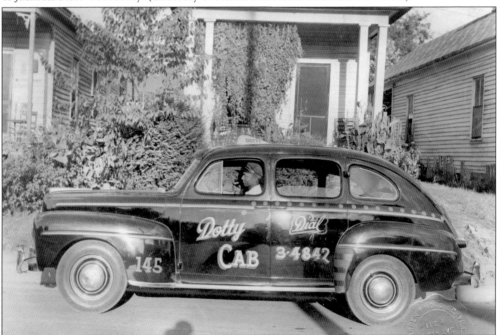

CAR 145 TO CENTRAL. An unidentified driver of a Dotty Cab displays his availability after dropping off a customer at this shotgun home on Farish Street. Notice the bouncing dots that appear above the company name. Dotty Cabs were radio equipped and stylish in their logo-designed cabs. Darden Photo Services of Meridian, Mississippi, took the images of Dotty Cab. (Courtesy of Smith Robertson Museum Archives.)

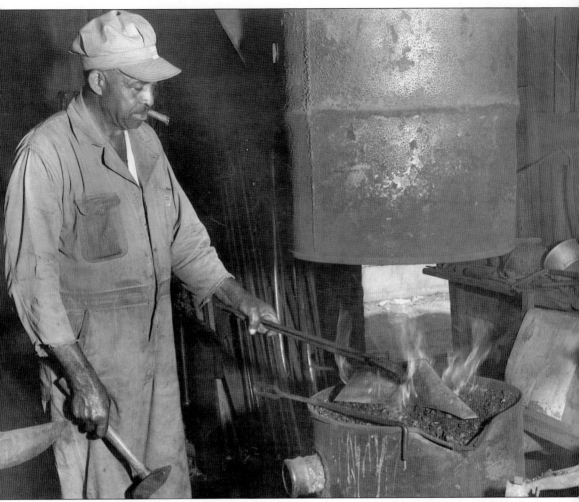

A LOST ART. Blacksmith Dewitt T. Mason is pictured later in life. Mason worked as a blacksmith for over 50 years. He learned his trade while attending Piney Woods Country Life School. Mason's education was interrupted by his service in World War II; however, he returned to Piney Woods to complete his educational training. He has been married to Cleotha Ward Mason for more than 50 years. They are the proud parents of three daughters. (Courtesy of Smith Robertson Museum Archives.)

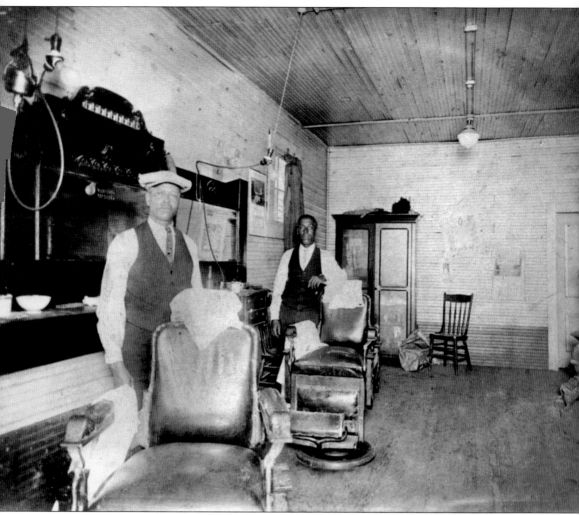

HAIR CUTS. Pictured in this 1930s barbershop are Clarence E. Gray (left) and his assistant, John Clay. Their barbershop was located at 414 Farish Street. African American barbers set the tone for economic independence and leadership. (Courtesy of Smith Robertson Museum Archives.)

RUTH OATIS WEIR. Ruth Oatis Weir is the third child of Carlia Edward Oatis and Carrie Bell Ford Oatis and grew up in West Jackson. Weir attended Jackson Public Schools and Jackson State College and is a graduate of Moore's School of Cosmetology of Jackson and Lydia's Beauty College in Chicago, Illinois. Weir was the proprietor of Ruth's Lounge, which was a successful variety store and lounge that served the students at neighboring Jackson State College and the African American community of West Jackson. Many visitors from out of the Jackson area met at Ruth's Lounge to hear live jazz music and socialize. Weir operated Ruth's Lounge until 1966. In 2007, Weir is the supervisor at Smith Robertson Senior Center, where she works to provide recreational and health-related activities for the older citizens of Jackson. (Courtesy of Ruth Oatis Weir.)

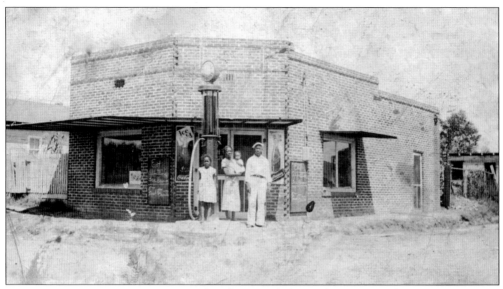

EVERETT STREET GROCERY STORE. This photograph shows the Oatis family stranding in front of their variety store located on Everett Street in Jackson in 1934. Carlia Oatis was the first to open a store of this kind in the West Jackson community. Pictured from left to right are Thelma Pearl Oatis, Carrie Bell Ford Oatis holding Ruth Oatis Weir, and Carlia E. Oatis. (Courtesy of Ruth Oatis Weir.)

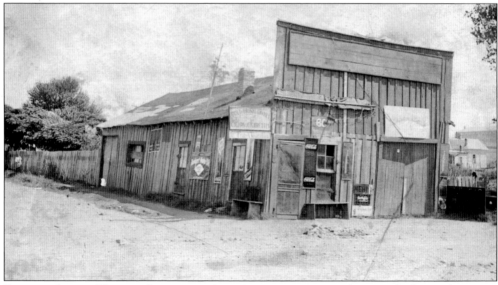

EVERETT STREET VARIETY STORE AND AUTO MECHANIC SHOP. Photographed is Carlia Oatis's Variety Store and Auto Mechanic Shop. The front of the store was occupied by the variety store, and the rear was an auto mechanic shop where Oatis worked on automobiles owned by community residents. Both Everett Street properties currently remain in the family and continue to serve the West Jackson community. (Courtesy of Ruth Oatis Weir.)

Five

FREEDOM NOW

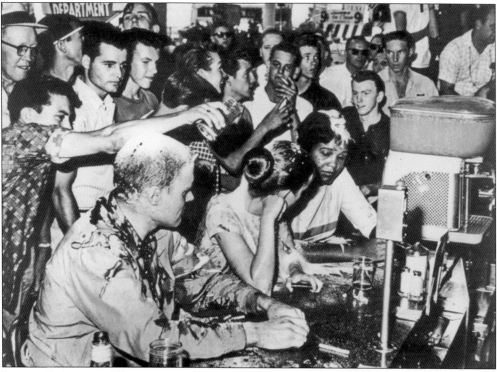

LUNCH IS SERVED. This iconographic image of the civil rights movement sit-ins is worth a thousand words. Students from Tougaloo College staged a sit-in at the Woolworth's lunch counter in Jackson, Mississippi. On May 23, 1963, (from left to right) John Salter, Joan Trumpauer, and Anne Moody occupy seats at the lunch counter to receive service in an attempt to desegregate the establishment. In the short term, their efforts failed. This image illustrates the human degradation these three individuals endured, as white patrons of Woolworth poured sugar, ketchup, and mustard on their heads. John Salter was a professor at Tougaloo College; Joan Trumpauer joined the civil rights campaign and remained in the South to complete her education at Tougaloo College; and Ann Moody, born in Mississippi, attended Tougaloo College during the height of the civil rights movement. Moody would later write a critically acclaimed autobiography entitled *Coming of Age in Mississippi*. During 1961, nearly 100 Southern cities and close to 70,000 students engaged in sit-ins with over 3,000 arrests. (Courtesy of Wisconsin Historical Society.)

1950

BIG KU KLUX KLAN RALLY

FRIDAY NIGHT, MAY 26 - 8 O'Clock

PLACE: On Lawn in Front of Imperial Palace 1-2 Mile
North of Five Points on Pocahontas Road

~~~~~EVERYBODY COME~~~~~

See The 20 Ft. Fiery Cross Burn and Klansmen Parading in Their Robes

Hear Slim Scoggins and His Roaming Cowboys

HEAR DR. SPINKS TELL YOU THE TRUTH ABOUT

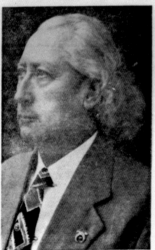

THE STATES RIGHT MOVEMENT
THE PROPOSED MEDICAL SCHOOL AND HOSPITAL
THE KNIGHTS OF THE KU KLUX KLAN

All Preachers, Public Officers and Ladies Urged to Come

•

ROOM TO PARK A THOUSAND CARS

•

You Can Sit In Your Car And Hear And See

BIG RALLY. This broadside advertising the coming of a KKK rally is significant in that it exemplifies the very nature of the blatant problem, making it seem quite improbable that change for African Americans would ever occur. (Courtesy of Mississippi Department of Archives and History.)

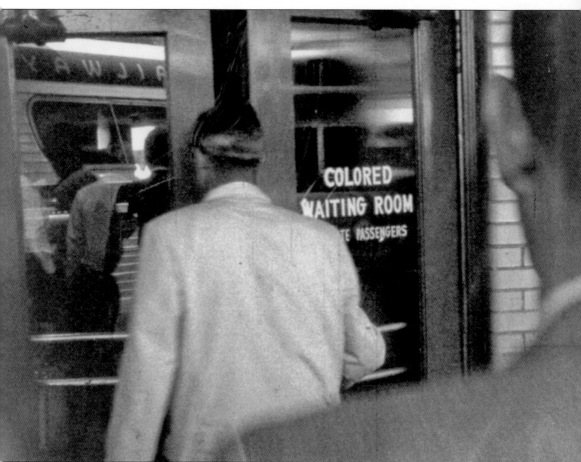

COLORED ONLY. The entryway into the Trailways bus station indicated a "Colored Waiting Room." In spite of the U.S. Supreme Court decision in *Boynton v. Virginia* (legislation desegregating interstate public transportation terminals), the local authorities of Jackson refused to concede to the federal law and maintained their sovereign right to uphold segregation. The Journey of Reconciliation in 1947 and the freedom rides of 1961, both organized by the Congress for Racial Equality (CORE), were conducted to challenge segregation in interstate transportation and their attendant colored waiting rooms. (Courtesy of Mississippi Department of Archives and History.)

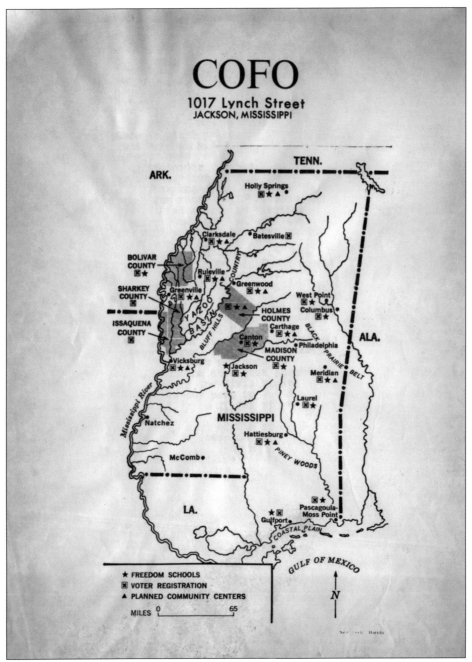

COFO

1017 Lynch Street
JACKSON, MISSISSIPPI

★ FREEDOM SCHOOLS
☒ VOTER REGISTRATION
▲ PLANNED COMMUNITY CENTERS

MILES 0 ____ 65

COUNCIL OF FEDERATED ORGANIZATIONS. One of the most proactive courses of action undertaken by the Council of Federated Organizations (COFO) was the 1964 Freedom Summer Project. COFO comprised the organizations of Congress for Racial Equality (CORE), National Association for the Advancement of Colored People (NAACP), Southern Christian Leadership Council (SCLC), and the Student Nonviolent Coordinating Committee (SNCC). This map illustrates the locations where COFO held Freedom Schools. While the map only indicates 19 locations, eventually there were nearly 30 Freedom Schools, as well as over two dozen voter registration centers operated throughout Mississippi. (Courtesy of Smith Robertson Museum Archives.)

THE STUDENT VOICE

VOL. 4, No. 4 The Student Nonviolent Coordinating Committee, 6 Raymond St., N.W. Atlanta, Ga. 30314 NOVEMBER 11, 1963

Over 70,000 Cast Freedom Ballots

HENRY-KING TICKET TOPS MOCK ELECTION

JACKSON, MISSISSIPPI - Over 70,000 disenfranchised Negroes in 200 communities throughout the state cast "Freedom Ballots" in churches, schools, poolrooms and "votemobiles" over a three-day period here.

For many, participation in the mock election was their first adventure into politics. The Freedom Vote candidates, Dr. Aaron Henry of Clarksdale and Rev. Edwin King of Jackson, received almost all of the votes cast, with less than 300 split between Democratic and Republican candidates.

There were 78,388 Freedom Votes cast Henry received 72,869.

Henry, state NAACP head and president of the Council of Federated Organizations (COFO), indicated the mock vote gave Mississippi's non-voting Negroes "a real choice between candidates." Both Republican and Democratic candidates ran on segregationist platforms. The Freedom Vote candidates- who also received write - in votes during the regular election November 5 - urged the state to provide "justice, equal education, jobs and voting

DR. AARON HENRY

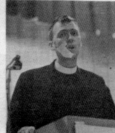

REV. EDWIN KING

rights."

The Freedom Ballot platform called for an end to segregation, including all public accommodations; fair employment a $1.25 minimum wage; better schools and a guaranteed right to vote.

Robert Moses, director of the Student Nonviolent Coordinating Committee's Mississippi vote drive and director of COFO said the campaign was "a political breakthrough in Mississippi." COFO leaders hope to use the activity surrounding the frive to push Negro vote attempts in the state. Over 100 campaign workers

were arrested on various charges during the three-week drive. At one time, 50 students from Yale University and several from Stanford University were in the state working with the Henry-King slate.

John Lewis, Chairman of SNCC, who worked in Mississippi during the last days of the campaign, said the Freedom Vote "is one of the most significant events of the civil rights movement."

James Forman, SNCC Executive Secretary said, "even though write - ins are not counted

CONTINUED TO PAGE 4

SELMA DRIVE FOR VOTES CONTINUES

SELMA, ALABAMA - A vote drive begun here in January, 1963 has mushroomed into the testing ground for SNCC's "One man - One vote" campaign.

Over 680 Negroes have appeared at the registrar's office since October 7.

They have braved wind and rain - and the possibility of being jailed - to stand in line outside the registrar's office waiting for a chance to take Alabama's complicated voter test.

In 1961, the U.S. Civil Rights Commission listed only 9% of the county's eligible Negroes as voters. A SNCC study (see SNCC SPECIAL REPORT: SELMA, ALABAMA) outlined the county's history of disfranchisment and listed instances of official interference into voting procedures.

When SNCC Executive Secretary James Forman addressed the first mass meeting called by the newly formed Dallas County Voters League, city and county police and members of the special "posse" surround-

CONTINUED TO PAGE 3

6 Freed In Americus Vow To Continue Work

AMERICUS, GEORGIA - Three field workers from the Student Nonviolent Coordinating Committee (SNCC) - who escaped a possible death sentence when a three-judge Federal panel freed them on Friday, November 1 - still face other charges here.

The three-Donald Harris of New York, Ralph Allen of Melrose, Massachusetts, and John Perdew of Denver, Colorado - were jailed here August 8 and charged with attempting to incite insurrection, unlawful assembly, rioting, obstruction

of a lawful arrest. Harris and Allen are charged further with assault and battery. All were denied bail.

Two others, 14-year-old Sallie Mae Durham and 19-year-old

CONTINUED TO PAGE 2

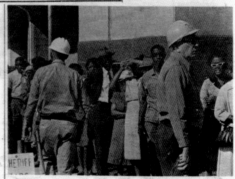

SELMA Negroes line up to register to vote. (SNCC Photo)

VOTE FOR FREEDOM. The *Student Voice* newsletter from Tougaloo College headlines the mock elections held by COFO. Edward King, the chaplain at Tougaloo, ran as vice president alongside Aaron Henry, then-chairman of the Mississippi state chapter of the NAACP. Over 70,000 African Americans cast their vote over a three-day period. The candidates' platform called for $1.25 minimum wage, an end to segregation, improved public schools, and guaranteed voting rights. (Courtesy of Mississippi Department of Archives and History.)

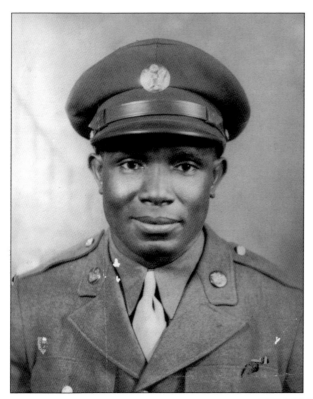

AMIZE MOORE IN UNIFORM. Amize Moore, seen in his War World II military uniform, was born on a Mississippi Delta plantation in 1911. Moore epitomizes the African American soldier's experience of fighting for freedom in Europe while enduring second-class citizenship in America. Moore, like many of the other one million African American World War II veterans, returned home seeking change. Moore, along with fellow civil rights activists Aaron Henry and Medgar Evers, joined forces with entrepreneur Dr. Howard and organized the Regional Council of Negro Leadership. Moore's leadership was central to the success of the voter registration component of Freedom Summer in 1964. (Courtesy of Wisconsin Historical Society.)

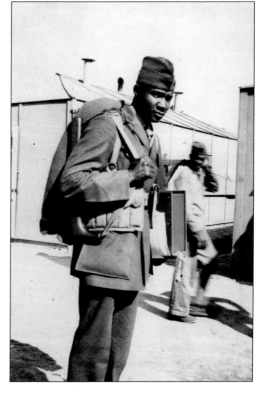

UNIDENTIFIED SOLDIER. War is never pleasant, yet millions of African American men enlisted both as patriotic duty and as a means to improve their lot in life. It is ironic that as citizens in a democratic nation, African American men went to war to feel free, and not just to defend the nation's principals of freedom commonly denied them. (Courtesy of Smith Robertson Museum Archives.)

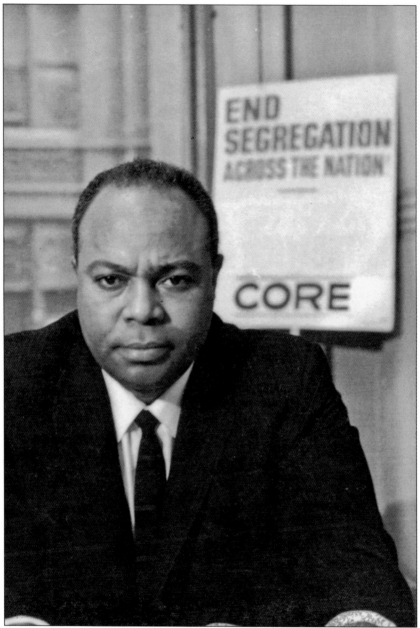

EQUALITY NOW. James Leonard Farmer Jr., born in Marshall, Texas, in 1920, would grow up to become one of the nation's leading figures on the internal "American War of Injustice," better known as the civil rights movement. He received his Ph.D. from Howard University in 1941 and, by 1942, along with two other colleagues, cofounded the Committee for Racial Equality in Chicago; the name would later change to the Congress for Racial Equality. In 1947, CORE organized what they called Journey of Reconciliation: 16 men, equally divided along racial lines, who traveled the upper South testing the laws on segregation of interstate transportation. The central foundation of CORE was its adherence to the philosophical teachings of change through non-violent actions espoused by way of Henry David Thoreau's writings read by Mohandas Gandhi and rearticulated by the writings of Krishnalal Shridharani. (Courtesy of Wisconsin Historical Society.)

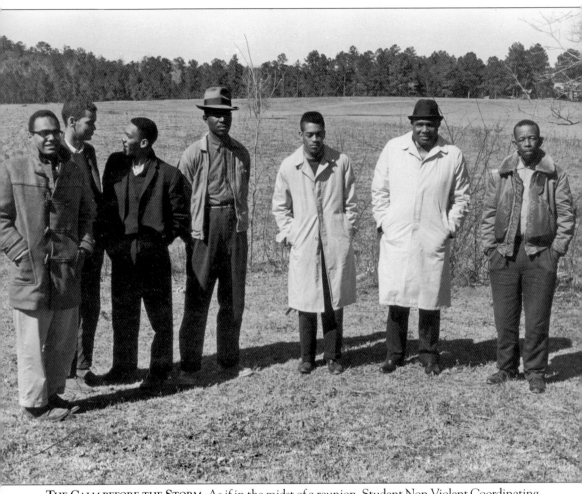

THE CALM BEFORE THE STORM. As if in the midst of a reunion, Student Non-Violent Coordinating Committee members (from left to right) Bob Moses, Julian Bond, Curtis Hayes, Willie Peacock, Hollis Watkins, Amize Moore, and E. W. Steptoe strike a pose. The image was taken on cool autumn day in Mississippi in 1962. (Courtesy of Wisconsin Historical Society.)

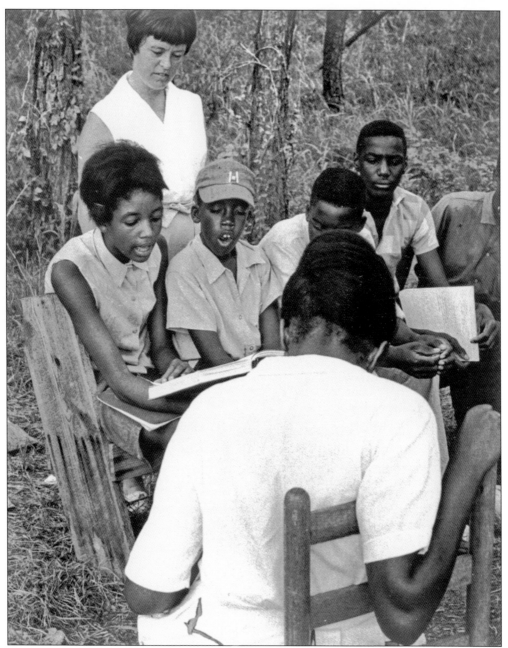

FREEDOM SCHOOLS. Often the Freedom School classrooms were outdoor settings with Northern white volunteers as teachers and Southern African Americans of all ages as students in the classrooms. The Council of Federated Organizations (COFO) organized the schools, initiated during the summer of 1964, nationally known as "Freedom Summer." The largely white staff of young teachers underwent intensive preparations for life in Mississippi. Previously some of the teachers had been conducting community organizing in the South, while others undertook their new assignments with a mixture of emotions. There are not exact numbers; however, approximately 400 or more Northern college students volunteered to teach at Freedom Schools. (Courtesy of Wisconsin Historical Society.)

NATIONAL ASSOCIATION FOR THE ADVANCEMENT OF COLORED PEOPLE
TWENTY WEST FORTIETH STREET • NEW YORK 18, N. Y. • BRyant 9-1400

Re: Tougaloo students
"Read-in"

April 1961

Dear Friend:

The picture you see here is that of a snarling police dog in Jackson, the capital of Mississippi, biting the arm of Rev. S. L. Whitney. The police dog was trained for his work by an ex-Nazi Storm Trooper.

Rev. Whitney is the pastor of the Farish Street Baptist Church, largest in Jackson. He is not a criminal. He was not engaged in disorderly conduct. He was not loud or boisterous. He was not jay-walking, nor was he arguing with a police officer.

Rev. Whitney was among some 100 persons who could not get into a filled courtroom March 29 to hear the trial of nine NAACP student members on a charge of seeking to use the "white" public library in Jackson. Rev. Whitney and others were told by police to stay on the other side of the street from the courthouse. This they did.

When the nine defendants appeared, making their way into the courthouse, the assembly of persons began to applaud. At that, the police on the courthouse steps and their two police dogs charged Rev. Whitney and the others, swinging clubs, blackjacks and pistol butts, cursing and egging on the two dogs.

Men, women and children fled in terror from this attack, made without any sort of warning, without even the usual police yell for the people to "move on." Many were beaten with clubs and pistol butts, including

NAACP Appeal for Support.

A copy of an official fund-raising letter from Roy Wilkins, executive secretary for the NAACP, is shown here. Wilkins implores readers to understand the nature of the brutality imposed upon African American citizens of Jackson by describing an incident with Pastor Whitney of Farish Street Baptist Church, the largest African American denomination in the city. On March 29, 1961, Rev. S. Leon Whitney attempted to enter the courthouse where the Tougaloo Nine hearings were held. His attempts failed, as police allowed attack dogs "trained by ex-Nazi storm troopers" to control the pastor's movements. The letter further states that then-governor Ross Barnett declared March 28, 1961, a day of reenactment of the state's 1861 secession from the union. (Courtesy of Mississippi Department of Archives and History.)

in and out of the state, who are sick and ashamed over the record of events.

Fifty thousand dollars is sought as a kick-off sum, with increased amounts needed as soon as the program gets under way.

Your contribution will translate your indignation into practical action. You cannot go to Jackson or Shubuta or Yazoo City or Indianola. But you can send your word to Mississippi Governor Ross Barnett. He has declared (March 28, 1961, at the re-enactment of Mississippi's 1861 secession from the Union) that the Confederacy is "an undying cause."

You can make a human, person-to-person move in sending your check; you can help rescue both white and black Mississippians from the hateful hand of the dead past.

Thank you for mailing it today.

Very sincerely yours,

Roy Wilkins
Executive Secretary

see back page →

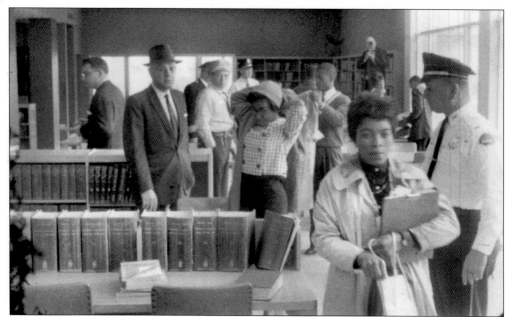

READ-IN. The Tougaloo Nine are captured here as they are arrested inside of the Jackson Public Library on March 27, 1961. In an act of civil disobedience, nine students of Tougaloo College decided to stage a "read-in" as an attempt to desegregate the Jackson Public Library. Their actions and subsequent arrests sparked protest and mass rallies throughout the city for several weeks. (Courtesy of Mississippi Department of Archives and History.)

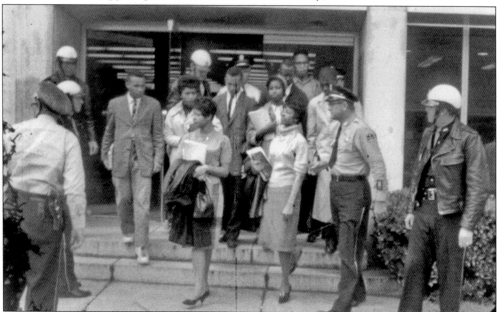

YOU ARE NOT WELCOME HERE. The Tougaloo Nine are escorted by the police as they leave the library located on State Street. Note that their body language is passive, while the expressions on their faces tell a different story. The well-orchestrated event drew national attention. The students were charged and spent several hours in jail until legal defense bailed them out. (Courtesy of Mississippi Department of Archives and History.)

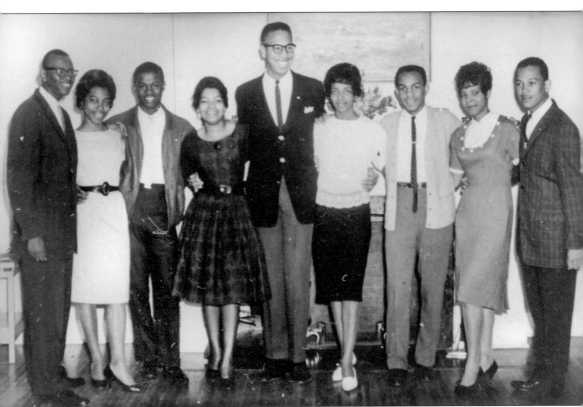

Tougaloo Nine. Following their release from jail a day and a half after their arrest, the Tougaloo Nine pose for reporters at a news conference held on the campus of Tougaloo College. From left to right are Joseph Jackson Jr., age 23, from Memphis, Tennessee; Geraldine Edwards, age 19, from Natchez, Mississippi; James Bradford, age 19, also from Memphis; Evelyn Pierce, age 19, born in Buffalo, New York; Albert Lassiter, age 19, from Vicksburg, Mississippi; Ethel Sawyer, age 20, from Memphis; Meredith Anding, age 19, from Jackson, Mississippi; Janice Jackson, age 21, from Clarksdale, Mississippi; and Alfred Cook, age 21, from Flint, Michigan. The Tougaloo Nine were released on a $1,000-per-person bond. (Courtesy of Tougaloo College Archives.)

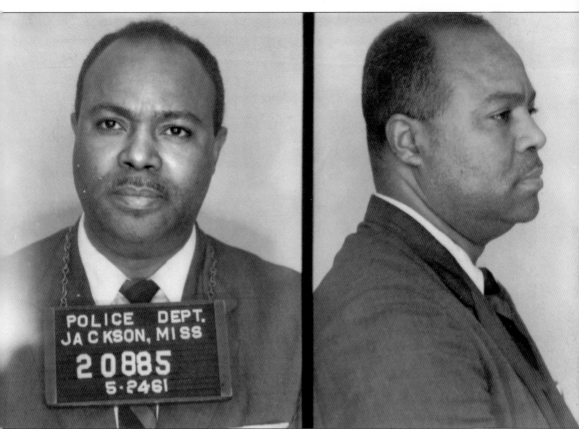

JAMES FARMER ARRESTED. This Jackson Police mug shot of James Farmer was taken on May 24, 1961, in response to the arrival of freedom riders in Jackson, Mississippi. In 1942, James Farmer Jr., Bernice Fisher, and George Houser founded the Congress for Racial Equality (CORE). By 1961, Farmer, at the age of 41, served as the national director of CORE. Prior to the 1961 freedom riders, CORE tested the issue of racial equality in 1947 by sending 16 volunteers, divided equally along the lines of racial makeup, on a bus odyssey through the states of the upper South. Nearly 20 years later, Farmer became the brainchild behind the 1961 freedom riders campaign. (Courtesy of Mississippi Department of Archives and History.)

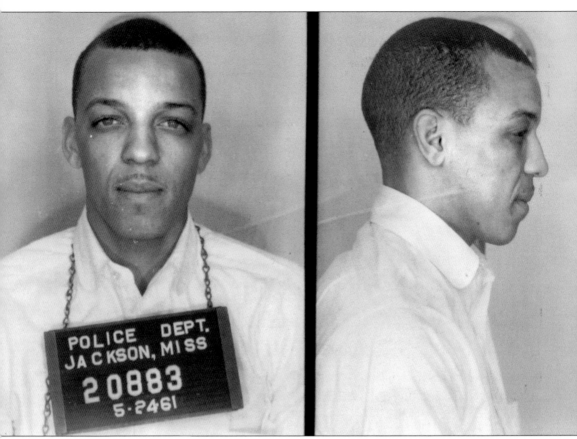

DAVE DENNIS ARRESTED. Dave Dennis and Bob Moses were the driving forces behind organizing white college students to converge on Mississippi. The goal was to spread out across the state and organize in preparation for the upcoming Democratic convention and to draw national attention to the plight of African Americans in Mississippi. While the interpersonal toll this campaign took on the lives of those involved will remain largely untold, the national headlines did bring to the American table the tragic murder of three COFO volunteers: James Chaney, Andrew Goodman, and Michael Schwerner. (Courtesy of Mississippi Department of Archives and History.)

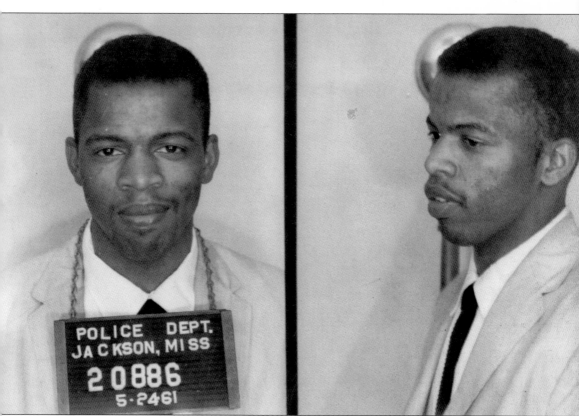

JOHN LEWIS ARRESTED. Prior to the appointment of Stokely Carmichael as chair of SNCC, John Lewis served in that capacity beginning in 1963. In 2007, John Lewis represents the 5th Congressional District as a Democrat from the State of Georgia. John Lewis was born in 1940 in Troy, Alabama, the son of sharecroppers. The battle scars of the civil rights movement, received first as a participant in the freedom riders campaign while the bus on which he was traveling was stopped in Montgomery, Alabama, are still visible upon Lewis's body. Evident from the mug shot image, Lewis journeyed on in spite of the severity of his injuries. (Courtesy of Mississippi Department of Archives and History.)

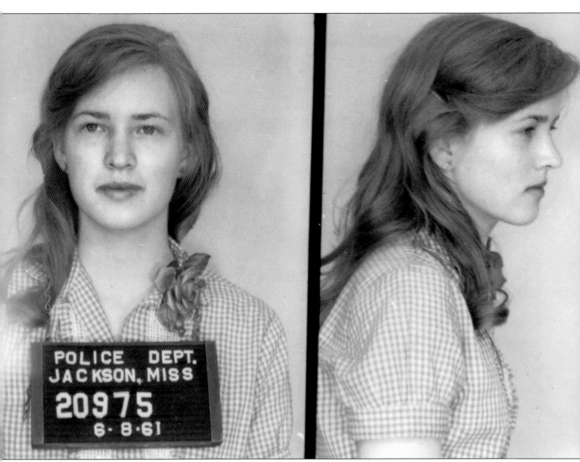

JOAN TRUMPAUER ARRESTED. Trumpauer was arrested on June 6, 1961. It is very likely that Trumpauer and others arrested on that day were a part of the overflow of freedom riders initially arrested in Jackson but sent to Parchman Penitentiary. Once imprisoned in the maximum-security section of the prison, freedom riders were subjected to abuses that ranged from forbidding them toothbrushes to removing the window screening, thereby allowing Mississippi Delta mosquitoes into the prison cells. The freedom riders were eventually hosed down with Dichloro-Diphenyl Trichloroethane (DDT), an agricultural pesticide banned in the United States in 1972 because it is a carcinogenic agent. (Courtesy of Mississippi Department of Archives and History.)

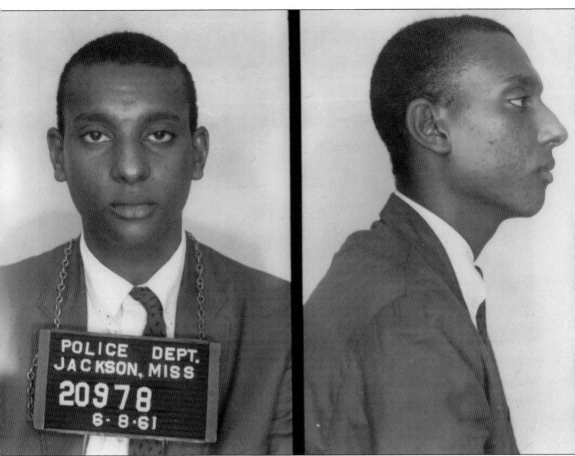

STOKELY CARMICHAEL ARRESTED. Carmichael was arrested on June 8, 1961, in Jackson, Mississippi. Carmichael was a member of the SNCC and in 1966 would become chair of the organization. Born in 1941 in Trinidad and Tobago, Carmichael immigrated to Harlem, New York, at the age of 11. He received an undergraduate degree in philosophy from Howard University in 1964. Stokely Carmichael was arrested at least twice in Mississippi. The first arrest, pictured in this mug shot, was for his participation as a freedom rider, and the second arrest was for his participation in the March Against Fear along with Martin Luther King Jr. and Floyd McKissick. (Courtesy of Mississippi Department of Archives and History.)

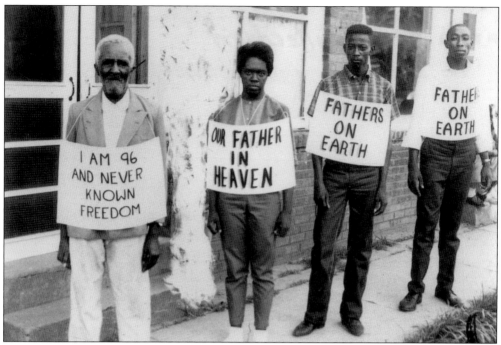

CONFESSIONS. This profound image of a 96 year old man's confession of his second-class citizenship epitomizes why African Americans recognized that the time was upon them to fight for changes in the American system. (Courtesy of Tougaloo College Archives.)

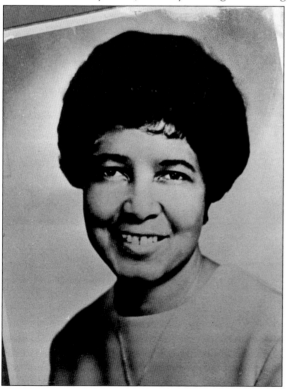

ONE WOMAN CAN MAKE A DIFFERENCE. Clarie Collins Harvey was the daughter of a very successful businessperson, Malachi Collins. By 1950, Clarie became the cofounder and the first board member of Farish Street YWCA. Collins Harvey was not only a mortuary entrepreneur—of which her success at Collins Funeral Homem still operating in Jackson, attests—but she was very active in her United Methodist church community. As with African American men of economic independence, Collins was also able to parlay her independence toward the good of civil rights in Jackson. Collins Harvey founded Womanpower Unlimited—a well-weaved network of over 200 women from across the nation lending their personal and financial resources to the cause of civil rights. (Courtesy of Smith Robertson Museum Archives.)

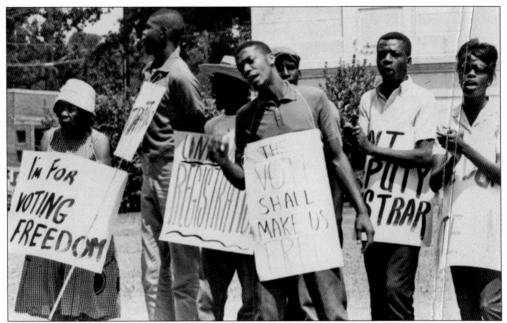

FREEDOM NOW. The image of mixed-age protestors draped in signage is emblematic of images seen across the South once African Americans overcame their fears of reprisal. In large part, the more nationally recognized civil rights events had the impact of creating space for the average African American citizen—the ones most impacted by the plight of Jim Crow—to stand up and be heard. (Courtesy of Smith Robertson Museum Archives.)

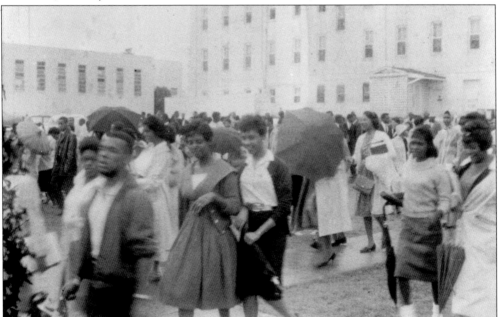

COME RAIN OR SHINE WE ARE MARCHING. The students at Jackson State University are in route to protest the arrest of the Tougaloo Nine. Over 1,000 protestors would eventually turn out in support of the nine students who conducted what they locally referred to as a "read-in." (Courtesy of Mississippi Department of Archives and History.)

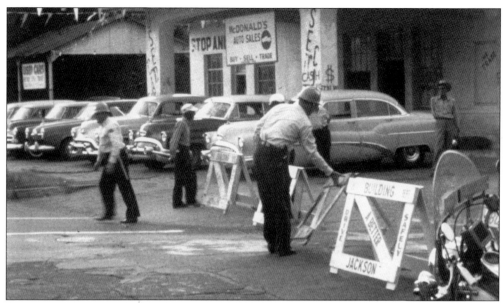

SIMPLE ACTS OF BRAVERY. The courage of the nine college students and the violent white response to their actions set in motion a chain reaction beginning with over 1,000 African Americans protesting outside the city jail where the nine were held on charges of disturbing the peace. Police are setting up roadblocks (note the irony of the text on the barricades) and later broke up the crowds with the use of attack dogs and police batons. (Courtesy of Mississippi Department of Archives and History.)

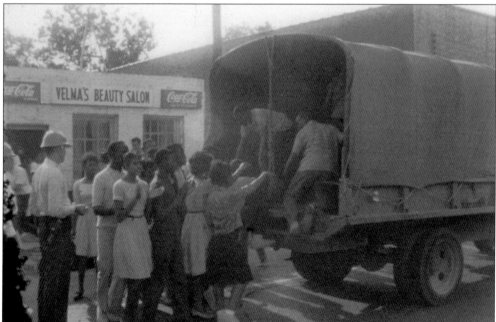

MASS ARRESTS. Seen being placed in the back of army trucks and paddy wagons, African Americans continue to present their grievances in the form of mass marches and protest rallies led by one or more of the national civil rights organizations and local African American churches. This scene took place on Farish Street. (Courtesy of Mississippi Department of Archives and History.)

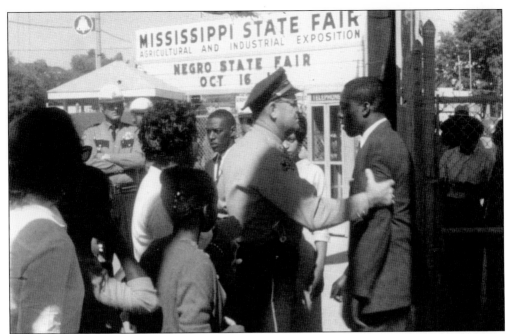

COLORED DAY AT THE FAIR. As tensions continued to rise (seemingly along with the temperature), African Americans, who were gathered for benign activities at the Colored Day of the state fair, were met with suspicion and, subsequently, attack dogs. (Courtesy of Mississippi Department of Archives and History.)

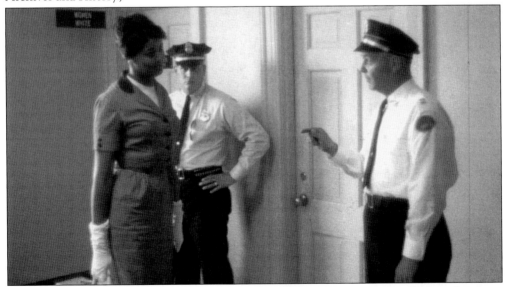

WHITES ONLY. This image remains an enigma as to whether or not it was an orchestrated event or sheer coincidence. Nonetheless, traveling from St. Louis, Missouri, Gwendolyn Jenkins at 27 years of age attempted to enter the white women's restroom at the airport in Jackson, Mississippi, on June 7, 1961. It should be noted that in spite of what appeared to be innocent acts of inconveniences, the majority of the civil disobedience actions during the civil rights movement were well thought out, prerehearsed actions enacted to achieve an arrest in pursuit of challenging the state laws at the federal level. (Courtesy of Mississippi Department of Archives and History.)

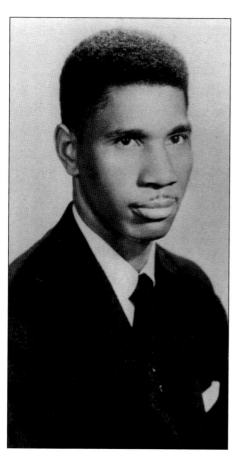

MEDGAR EVERS. Born on July 2, 1925, to pious parents who held membership in the Church of God in Christ, Medgar's faith saw him through the hard times of voter registration drives and death threats. Evers began his civil rights actions early in life, working with Dr. T. R. M. Howard and Aaron Henry when they organized a boycott against gas stations that did not allow African Americans use of their restrooms. Medgar Evers, prior to James Meredith, applied for admission to the law school of the University of Mississippi and was denied because his application lacked two letters of recommendation from Evers's community. Undaunted by this rejection, Evers accepted a position with the NAACP, making him, in 1954, the first field secretary for the organization in Mississippi and the nation. Shortly after the clock struck midnight on June 11, 1963, Medgar Evers was gunned down as he exited his car returning from a poorly attended civil rights rally at the New Jerusalem Baptist Church in Jackson. The weapon used in the assassination belonged to Byron De La Beckwith. Twice De La Beckwith was tried, and mistrials were declared. It was not until 1994 that justice was won in the murder of Medgar Evers, when a mixed-race jury found De La Beckwith guilty, and he was sentenced to life in prison. (Courtesy of Tougaloo College Archives.)

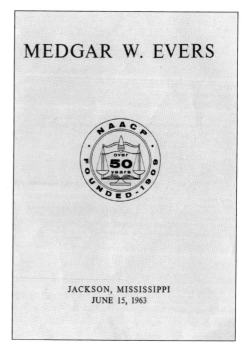

THE FUNERAL PROGRAM OF MEDGAR EVERS. This program was as unassuming as the man himself. (Courtesy of Smith Robertson Museum Archives.)

THE DUKE. The ever-popular jazz musician Duke Ellington is seen backstage before a concert scheduled at Tougaloo College. Ellington is to perform with the Tougaloo orchestra. However, the smiles so evident in this image turned to sorrow when news of the assassination of Medgar Evers pierced their ears. (Courtesy of Tougaloo College Archives.)

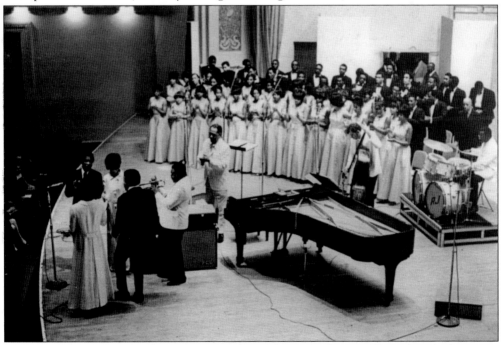

THE CONCERT. In spite of the tragic news, the performance went as planned, with the caveat that the concert was dedicated to slain civil rights leader Medgar Evers. (Courtesy of Tougaloo College Archives.)

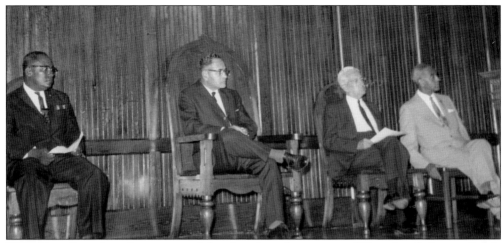

U.N. DAY. Seated on the rostrum of the chapel on the campus of Tougaloo College is Ralph Bunch (second from left), guest speaker for the 1963 United Nations Day celebrations held on campus. In 1936, Bunch served as the codirector of the Institute of Race Relations at Swarthmore College. By then, he had received his graduate degree from Harvard University and gone on to teach at Howard University while working on his Ph.D., also from Harvard. Bunch may best be noted for his work with the United Nations. He began his career there in 1946 and from 1947 to 1949 worked as an assistant to the U.N. Special Committee on Palestine and later as secretary of the U.N. Palestine Commission. His actions, which resulted in an armistice agreement between Israel and the Arab States, won Bunch the Noble Peace Prize in 1950. (Courtesy of Tougaloo College Archives.)

RALPH BUNCH. Bunch was born August 7, 1904, in Detroit, Michigan. Bunch was his Los Angeles high school valedictorian and went on to study political science at Harvard University after receiving a bachelor degree from the University of California at Los Angeles. Ralph Bunch taught at Howard University while also working toward receiving a doctorate from Harvard, which he completed in 1934. From 1928 through 1950, Bunch chaired the Department of Political Science at Howard and taught from 1950 to 1952 at Harvard University. Ralph Bunch declined the offer to serve in the Truman administration as assistant secretary of state because of the segregated housing in Washington, D.C. (Courtesy of Tougaloo College Archives.)

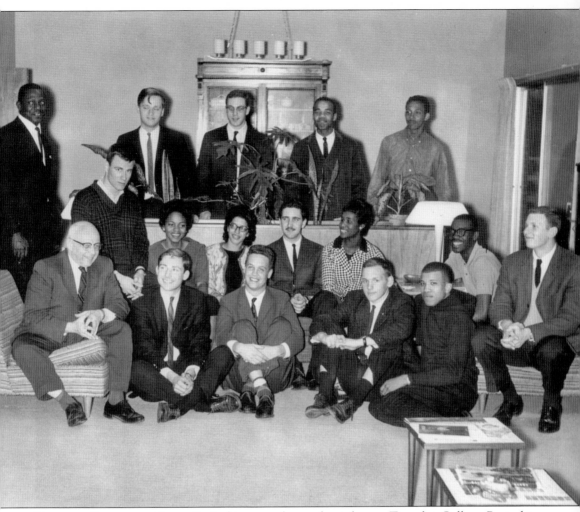

BORINSKI INSTITUTE. Ernest Borinski was professor of sociology at Tougaloo College. Borinski taught at Tougaloo from 1947 until his death in 1983. The college has honored the legacy of Dr. Borinski with a campus building in his name. Dr. Borinski held sociology science forums exposing the Tougaloo students to discussions in social issues of the day. The forums were frequented by a mixed-race gathering and featured some of America's leading activists at the time. This image depicts audience members of the Borinski sociology science forums. Note that Dr. Borinski is seated on the front row far left, and Jerry Ward, then a student at Tougaloo College, is seated front row far right. Dr. Ward returned to teach English and literature at Tougaloo College and is a noted scholar of Richard Wright. (Courtesy of Tougaloo College Archives.)

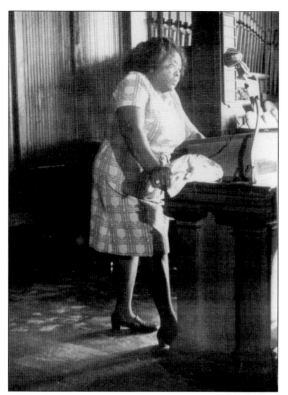

FANNIE LOU HAMER. Hamer was born in 1917, the youngest of 20 children born to sharecropper parents. Fannie Lou Hamer began working at the age of 12, which may account for her often-quoted phrase, "I am sick and tired of being sick and tired." By the time Hamer became active in the civil rights movement, she and others of the Mississippi Delta had every reason to feel such sentiment. Hamer was initially exposed to civil rights issues through the Regional Council of Negro Leadership (RCNL), and it was after attending one of its meetings that she answered the call from Student Nonviolent Coordinating Committee (SNCC) speaker Rev. James Bevel. Judging by Hamer's posture of in this image of her visit to Tougaloo College to speak at one of the Borinski forums, an impairment had occurred after she had received a merciless beating at the hands of police in Winona, Mississippi, in 1963. (Courtesy of Tougaloo College Archives.)

OWENS AND HAMER. Hamer received an honorary doctorate from Tougaloo College. Dr. George Owens, president of Tougaloo College, presented the degree to Hamer. In her acceptance speech, Hamer told those in attendance that, "we have been educated but education has not set us free." Fannie Lou Hamer died in 1977 at the age of 59 from breast cancer. (Courtesy of Smith Robertson Museum Archives.)

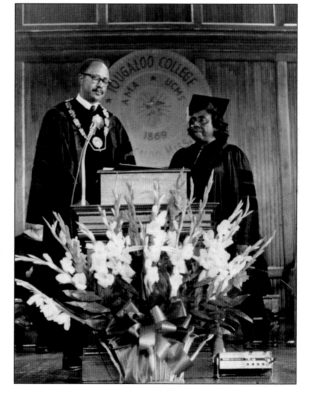

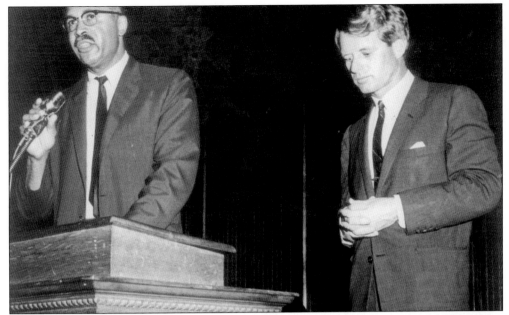

OWENS AND KENNEDY. Dr. George Owens, the first African American president of Tougaloo College, introduces Bobby Kennedy at a Borinski Institute Social Science Forum around 1966. At the time, Robert F. Kennedy was the Democratic senator from New York, having previously served as the U.S. attorney general from 1961 to 1964 under his older brother's presidential administration. (Courtesy of Tougaloo College Archives.)

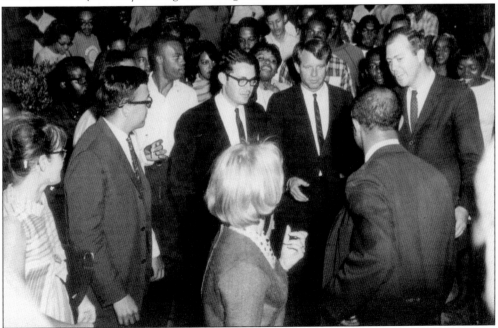

BOBBY KENNEDY AND REV. ED KING. Standing in the center of a crowd on the campus of Tougaloo College is Bobby Kennedy, brother of Pres. John F. Kennedy, on one of his visits to Mississippi. Standing next to Kennedy on the right is Rev. Ed King, chaplain at Tougaloo College and civil rights activist. (Courtesy of Tougaloo College Archives.)

JOAN SIGNS AUTOGRAPHS. Popular folk singer Joan Baez signs an autograph for an audience member attending the Borinski forum. Baez lent her talents (as did other performers such as Harry Belafonte, Mahalia Jackson, and Duke Ellington) to the greater cause of civil rights. Joan and her three sisters are the daughters of Albert and Joan Baez. Her travels in her youth brought her into contact with cultural and economic differences other than those with which she and her family were familiar. A self-taught musician, Baez was greatly influenced by the music of Pete Seeger. By the age of 15, she had met and befriended Martin Luther King Jr. Their friendship and her own early-developed beliefs in social justice continue to shape Baez's human experiences. (Courtesy of Tougaloo College Archives.)

SHIRLEY CHISHOLM. Chisholm was born on November 30, 1924, and became the first African American woman elected to congress. Chisholm served seven terms from 1968 to 1983. Chisholm is also noted for being the first African American woman to run for the U.S. presidency, receiving over 150 delegate votes. Shirley Chisholm was a founding member of the Congressional Black Caucus and is pictured delivering a speech at one of the many Borinski Sociology Science Forums held at Tougaloo College, *c.* 1970. (Courtesy of Tougaloo College Archives.)

JULIAN BOND. During his days as chair of the SNCC in the mid-1960s, Bond gives a speech at the Borinski Sociology Science Forums. The forums were held in the historic Woodworth Chapel, erected in 1901 on the campus of Tougaloo College. Bond, born on January 14, 1940, was a student at Morehouse College in Atlanta, Georgia, when he cofounded the SNCC. Currently Julian Bond serves as chairman of NAACP. (Courtesy of Tougaloo College Archives.)

STOKELY CARMICHAEL. Carmichael at the podium delivers a lecture in Woodworth Chapel on the campus of Tougaloo College, c. 1966. His speech undoubtedly references the works of Malcolm X. This image marks a turning point in the political views of Carmichael. He had begun to view nonviolent political actions as a tactic and not a way of life—a tactic that from his vantage point was in need of a revolution. (Courtesy of Tougaloo College Archives.)

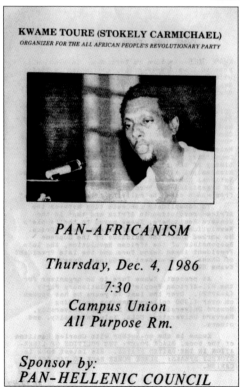

KWAME TOURE (STOKELY CARMICHAEL)
ORGANIZER FOR THE ALL AFRICAN PEOPLE'S REVOLUTIONARY PARTY

PAN-AFRICANISM

Thursday, Dec. 4, 1986

7:30
Campus Union
All Purpose Rm.

Sponsor by:
PAN-HELLENIC COUNCIL

PAN AFRICANISM. This flyer advertising a speech to be given by Kwame Toure, formerly known as Stokely Carmichael, marks a complete revolution on the part of Carmichael's politics. By 1986, Toure had moved to the Republic of Guinea in West Africa. As early as 1968 he changed his name to represent the two most popular and leading figures in the Pan African movement, Ahmed Sékou Touré, the president of Guinea, and the Ghanaian president Kwame Nkrumah. Kwame Toure is credited with the coinage of two significant phrases in the struggle for civil rights: "black power" became popularized via Toure's cries in a Greenwood, Mississippi, park while he participated in a state wide march on behalf of James Meredith; the phrase "institutional racism" was introduced by Toure to mean "the collective failure of an organization to provide an appropriate and professional service to people because of their color, culture, or ethnic origin." Kwame Toure died in Guinea on November 15, 1998, yet we still hear his voice answering the call, "ready for the revolution." (Courtesy of Smith Robertson Museum Archives.)

THE SHOULDERS WE STAND ON. As an educator, Gladys Noel Bates demonstrated leadership outside the classroom when she became the plaintiff in the first civil rights case in the state of Mississippi in 1948. Bates initiated a lawsuit to equalize the pay between African American and white teachers of the Jackson school system. The case went all the way to the U.S. Supreme Court after a four-year legal journey. The high courts refused to hear the case and sent the case back to the lower courts. As the legal suit made its way through the courts, parity between African American and white teachers occurred in 1951, rendering the legal case moot. However, as retribution for filing the suit, both Bates and her husband (also a teacher) were blacklisted and forced to relocate out of state to continue their careers as educators. (Courtesy of Smith Robertson Museum Archives.)

Six

BLUES EXPRESSIONS

RABBIT FOOT MINSTREL SHOWS. The origin of minstrel shows dates back to 1830. While the majority of African Americans toiled under slavery, a few were experiencing life as professional entertainers. The minstrel show took place under a bib tent in town. In Jackson, minstrel shows were set up on the outskirts of Farish Street, and these performances drew a mixed-race audience filled to seating capacity. One common aspect of minstrel shows was the white comedians who wore blackface, a process of smearing burned cork ash over the face to mimic the appearance of African Americans, albeit a very exaggerated appearance. Ironically, when African Americans joined the minstrels, they too wore blackface. Historians have viewed this as a parody upon parodies in that whites were poking fun at African American minstrels, and, in turn, African American minstrel performers were poking fun at white minstrel comedians. The Rabbit Foot Minstrel was a specific touring company that offered Jackson audiences entertainment. (Courtesy of the Mississippi Department of Archives and History.)

MARGARET WALKER ALEXANDER, PH.D. Dr. Alexander was born in Birmingham, Alabama, in 1915. Dr. Alexander, a graduate of Northwestern University in 1935 and a former writer for the Federal Writer's Project, is best known for her novel *Jubilee* and her poem "For My People," for which she received the Yale Younger Poets Award in 1942. By 1966, Dr. Alexander was professor of literature at Jackson State University in Jackson. Two years later and two years subsequent to the publication of her novel *Jubilee*, Alexander established the Institute for the Study of History, Life, and Culture of Black People. The institute now bears her name as the Margaret Walker Alexander National Research Center on the campus of Jackson State University. (Courtesy of the Vivian Harsh Research Collection of Afro-American History and Literature of the Chicago Public Library.)

RICHARD NATHANIEL WRIGHT. Wright was born September 8, 1908, in Roxie, Mississippi, located about 22 miles east of Natchez, Mississippi. Wright's family moved to Memphis, where his father, Nathaniel, abandoned them. Wright and his brother and mother moved to Jackson to live with relatives. While living in Jackson, Wright attended Smith Robertson School. He graduated valedictorian of his class in 1925. After school, Wright moved to Chicago where he became affiliated with the John Reed Club and wrote for their magazine called *New Masses*. Wright left Chicago for New York and began work on a series of short stories called *Uncle Tom's Children*, published in 1937. *Uncle Tom's Children* earned Wright a Guggenheim Fellowship, which allowed him to publish his first novel, *Native Son*, in 1940. In 1946, Wright moved to Paris, France, and became friends with Jean Paul Sartre and Albert Camus. Wright died in Paris on November 28, 1960. (Courtesy of the Vivian Harsh Research Collection of Afro-American History and Literature of the Chicago Public Library.)

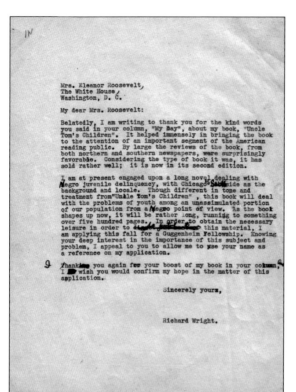

LETTER TO ELEANOR ROOSEVELT FROM RICHARD WRIGHT. Richard Wright wrote a letter to First Lady Eleanor Roosevelt thanking her for commenting on his book of short stories called *Uncle Tom's Children*, which was published in 1938. The letter also spoke about Wright's developing another novel and the fact that he was applying for a Guggenheim Fellowship. He asked First Lady Roosevelt if he could use her as a reference on his application. (Courtesy of Smith Robertson Museum Archives and Julia Wright.)

LETTER FROM ELEANOR ROOSEVELT TO RICHARD WRIGHT. Eleanor Roosevelt wrote a letter to Wright on November 17, 1948, from the Hotel Crillion inviting him to have lunch with her at the hotel. (Courtesy of Smith Robertson Museum Archives and Julia Wright.)

623 East 63rd Street
Chicago, Illinois
April 9, 1945

Dear Mr. Wright,

You've been a literary hero of mine for years and I'm certain to be impressed by anything, for or against, that you have to say about my efforts.

I haven't a letter from Mr. Embree __ but some weeks ago a Miss Haygood (nice) of the Rosenwald staff called me and invited me to lunch at their office. Alice Browning of Negro Story was invited too. There I met Mr. Embree, and the others. A very pleasant afternoon. Mr. Embree told me how kindly you had spoken of me.

Oh. I want to tell you that I took your advice about writing a long poem for the book, one that would express a little of my personal feeling about things and rather tie the others together. I hope you'll like it.

About Black Boy. I hated reaching the last page. I wanted the story to go on and on.

I've bad news for you. One of my best friends, and a friend of yours too, was killed in Germany at the "front" March 20th __ Ed Bland. He was so kind, wasn't he? We are re-naming the fifty dollar poetry prize that we give to Poetry, A Magazine of Verse: from the Fellowship Prize to the Edward Bland Prize.

Yes, I'm interested in fiction writing too.

Sincerely,

Gwendolyn Brooks

LETTER TO RICHARD WRIGHT FROM GWENDOLYN BROOKS. Gwendolyn Elizabeth Brooks was born in Topeka, Kansas, on June 7, 1917. When Brooks was only six weeks old, her family moved to Chicago, Illinois, where she grew up. Her enthusiasm for reading and writing was encouraged by her parents. Brooks's mother took her to meet Harlem Renaissance poets Langston Hughes and James Weldon Johnson. This letter written to Richard Wright on April 9, 1945, speaks to how much Brooks admired Wright, and it is testament to how much African American writers and artists of that era encouraged and supported each other. (Courtesy of the Smith Robertson Museum Archives and Julia Wright.)

COVER OF RICHARD WRIGHT'S NOVEL BLACK BOY. Wright's novel *Black Boy* was published in 1945. It describes his early life, from Roxie, Mississippi, through his move to Chicago, and his clashes with his Seventh-Day Adventist family in Jackson and his difficulty negotiating the vicissitudes of being African American in a racist society. (Courtesy of Smith Robertson Museum Archives and Gregory A. Jones.)

COVER OF RICHARD WRIGHT'S NOVEL AMERICAN HUNGER. Richard Wright's *American Hunger* was published posthumously in 1977. The novel was originally intended to be the second book after *Black Boy* was published in 1945. The novel outlines Wright's involvement with the John Reed Club and the Communist Party, which he left in 1942. Though the book implies that it was earlier, it was not made known that he left the Communist Party until 1944. (Courtesy of Smith Robertson Museum Archives and Gregory A. Jones.)

MALE CONCERT SINGER AND PIANIST AT TOUGALOO COLLEGE. Tougaloo College, like many historically black colleges and universities, has had a longstanding tradition of fostering all forms of the arts. Music concerts are a part of a well-established tradition at Tougaloo College. Woodworth Chapel on the college campus has been the venue of many outstanding choral concerts and vocal recitals. This photograph shows a Tougaloo student performing an aria at a recital in the chapel on campus. (Courtesy of the Tougaloo College Archives.)

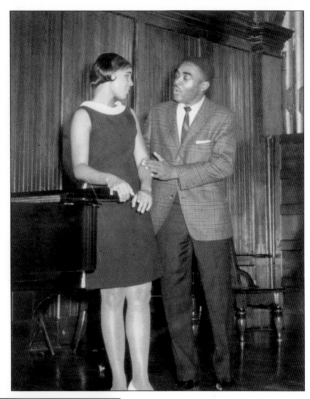

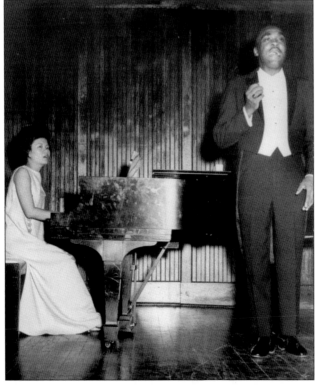

TWO CONCERT SINGERS AT TOUGALOO COLLEGE. Two music majors perform in the chapel at Tougaloo College. Many notable singers have come from Tougaloo. Among them are Walter Turnbull, founder and director of the famed Boys Choir of Harlem; Larry Robinson, music professor and former artistic director of the Boys Choir of Harlem; and Robert Honeysucker, internationally renowned concert singer currently based in Cambridge, Massachusetts. (Courtesy of the Tougaloo College Archives.)

Jackson State University
Utica Junior College

OPERA/SOUTH

in its tenth production for
Mississippi Inter-Collegiate Opera Guild

HILDA HARRIS

ULYSSES KAY's

JUBILEE

World Premiere Performance

MARCIA BALDWIN

JAMES DE PREIST

Conductor

DONALD DORR

Designer and Director

DOLORES ARDOYNO

General Manager

CLYDE WALKER

JACKSON AUDITORIUM
Jackson, Mississippi
Saturday, November 20, 1976
8:15 p.m.

AMERICAN REVOLUTION BICENTENNIAL
1776-1976

VINSON COLE

OPERA/SOUTH PROGRAM BOOKLET, JUBILEE. This program booklet is for the world performance of Ulysses Kay's opera *Jubilee*, based on the novel written by Margaret Walker Alexander. This production was produced by Opera/South at the Jackson Municipal Auditorium in Jackson on November 20, 1976. A retired music teacher from Xavier University of Louisiana in New Orleans by the name of Sr. M. Elise, SBS, approached the music department chairpeople of three African American Mississippi colleges—Tougaloo College, Utica Junior College, and Jackson State University—to produce a production of *Aida*. The music chairpeople went to their respective presidents for permission and support. The chairmen were granted permission, and plans proceeded to become a legally chartered organization. The Mississippi Intercollegiate Opera Guild was born on February 18, 1971. The production arm of the guild was called Opera/South. (Courtesy of Smith Robertson Museum Archives.)

NIKKI GIOVANNI AND TOUGALOO COLLEGE CHOIR. Tougaloo College often invited national writers and scholars to the campus. Oftentimes, these visitors would lecture about the social state of the country and also new works they had produced. One of these visitors is poet Nikki Giovanni (seated in front), who is shown here with the Tougaloo College choir inside of the chapel on the campus of Tougaloo College. (Courtesy of Tougaloo College.)

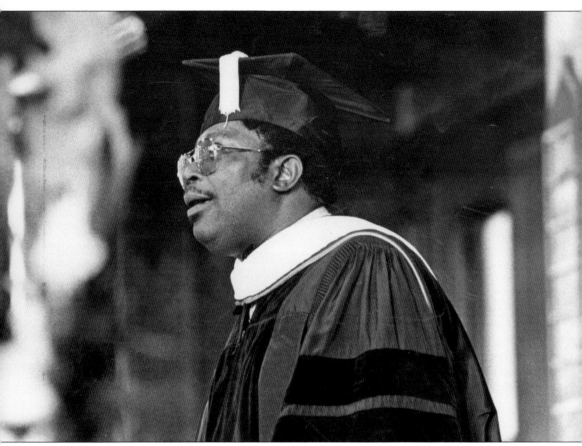

B. B. KING IN ACADEMIC REGALIA. The photograph shows the legendary blues guitarist and singer-songwriter making a speech after receiving an honorary doctorate from Tougaloo College. B. B. King was born September 16, 1925, in Itta Bena, Mississippi, about 125 miles north of Jackson. In 1947, B. B. King began recording songs under contract with Los Angeles–based RPM Records. King was also a disk jockey in Memphis, Tennessee, where he gained the nickname "Beale Blues Boy," later shortened to B. B. (Courtesy of Smith Robertson Museum Archives.)

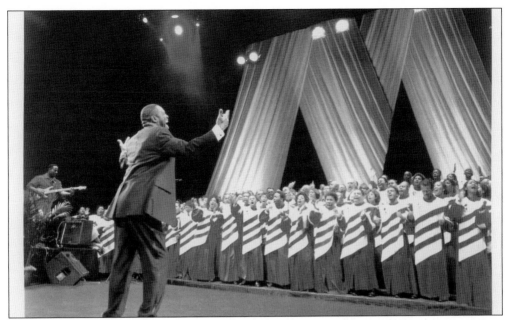

MISSISSIPPI MASS CHOIR. Founder of the Mississippi Mass Choir Frank Williams began singing gospel music at an early age. Williams performed with his brothers as the Williams Brothers; later, they joined the Jackson Southernaires. Williams had a vision to bring great voices of Mississippi together and approached Davis Curry, who was a gospel music artist, and they formed the Mississippi Mass Choir. (Courtesy of Malaco Records of Jackson.)

FARISH STREET HERITAGE FESTIVAL POSTER, 1996. This poster advertising the 1996 Farish Street Heritage Festival was designed by Tougaloo College art professor and Jackson native Johnnie Mae Mayberry Gilbert. In 1978, Faharah Seba, a reporter with the *Jackson Advocate*, convinced *Jackson Advocate* publisher Charles Tisdale, John Reese, and business people along Farish Street to organize a street festival; thus, the Farish Street Heritage Festival was born. Their aim was to draw attention to the Farish Street Historic Neighborhood's rich cultural legacy. The event was a success, and in 1979, the Mississippi Cultural Arts Coalition was established to present the Farish Street Festival and other arts and cultural programs in the community. The Mississippi Cultural Arts Coalition presented the festival until 1995. (Courtesy of Smith Robertson Museum Archives and Theresa King.)

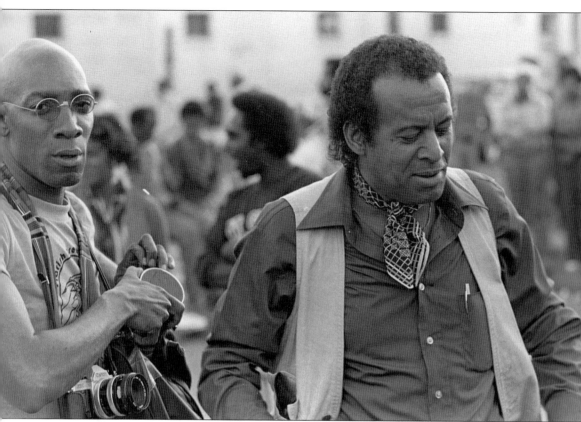

JOHN REESE AND JOHN PARKS. This photograph shows John Reese on the right and John Parks on the left at one of the early Farish Street Heritage Festivals. Reese, a longtime supporter of arts and culture, is a cultural icon in Jackson. His great interest was preserving the jazz heritage in Jackson. Reese founded the Black Arts Music Society (BAMS), which was dedicated to supporting jazz music and African American arts and culture in Jackson. Reese was a great supporter of the arts scene, and he often played host to nationally known artists such as John Parks (with camera around his neck.) A nationally known dancer and choreographer, Parks danced with the Alvin Ailey American Dance Theatre and appeared in many films such as *The Wiz*, *Malcolm X*, and *A Rage in Harlem*. (Courtesy of Cosmo-D Productions.)

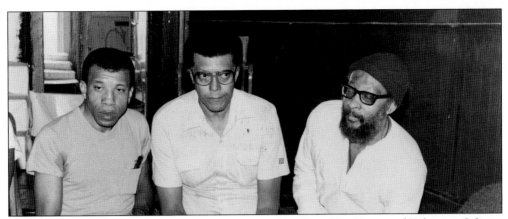

NOTED AUTHORS. From left to right are Jerry W. Ward Jr., Ph.D.; Tom Dent; and Kalamu ya Salaam. Dr. Ward was born in Washington, D.C., on July 31, 1943, and moved to Mississippi in 1949. He was a student at Tougaloo College from 1960 until 1964, after which he earned his master's of science in English from the Illinois Institute of Technology and his Ph.D. from the University of Virginia. Ward taught at Tougaloo College from 1970 to 2002. Ward is a noted scholar of Richard Wright. Tom Dent, a native of New Orleans, wrote *Southern Journey: A Return to the Civil Rights Movement*. He served as the executive director of the New Orleans Jazz and Heritage Foundation. He was the coeditor of *The Free Southern Theater by the Free Southern Theater* and authored two volumes of poetry, *Magnolia Street* and *Blues and River Songs*. Kalamu ya Salaam was born in 1947 in New Orleans. Ya Salaam is noted for his anthologized works in *Black Theater USA* published in 1974, *New Plays for Black Theater* published in 1999, and *Black Southern Voices* published in 1992. (Courtesy of Cosmo-D Productions, Dr. Jerry Ward Jr., and Hollis Watkins.)

MUSICIANS PLAYING IN JACKSON. This photograph shows four jazz musicians playing, and in the middle is famed jazz vocalist and Jackson native Cassandra Wilson. The gentleman playing the upright bass is noted musician and father of Wilson, Herman Fowlkes Jr., who grew up in Chicago, Illinois. While stationed at Camp Shelby in Hattiesburg, Mississippi, Fowlkes exercised his talent as a musician. He met his future wife, Mary McDaniel, and promised to return to Mississippi after he came back from Europe. Fowlkes was considered a premier bassist and can be heard on many recordings by Sonny Boy Williamson and Jerry McCain. Wilson is the youngest daughter of Fowlkes and Mary McDaniel Fowlkes, both of whom instilled the love of music in Wilson at an early age. During college, Wilson spent her nights singing in many of Jackson's coffeehouses. Local musician Alvin Fielder and arts advocate John Reese provided her with the first opportunity to perform bebop. (Courtesy of Cosmo-D Productions.)

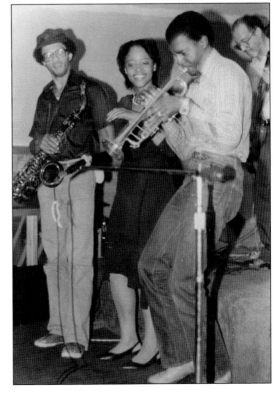

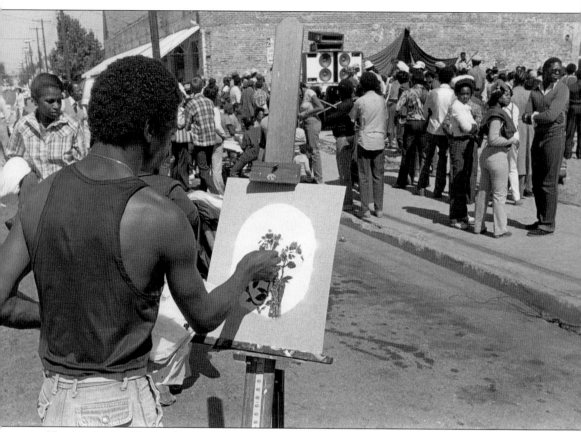

VISUAL ART ON FARISH STREET, C. 1978. One of the many laudable features of the Farish Street Heritage Festival is the opportunity that it provides visual artists to create and display their art. This photograph shows a painter at work on a painting, possibly for a patron at the festival. (Courtesy of Cosmo-D Productions.)

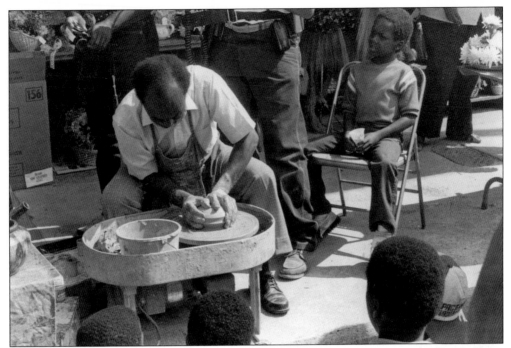

MARCUS DOUYON. Professor Douyon is shown creating a ceramic piece at the Farish Street Heritage Festival. Marcus Douyon, a native of Les Cayes, Haiti, taught art and ceramics at Jackson State University for 41 years. (Courtesy of Cosmo-D Productions.)

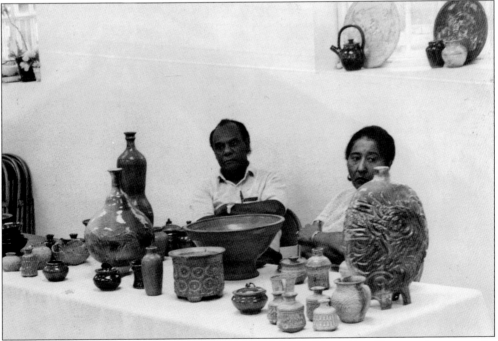

MARCUS DOUYON AND LUCE ROC DOUYON. Marcus and Luce Roc Douyon sit at an artist booth at the Farish Street Heritage Festival. The table displays Prof. Marcus Douyon's ceramics. (Courtesy of Cosmo-D Productions.)

TONEA STEWART, PH.D. Dr. Tonea Stewart is an African American actress and university professor. Stewart is best known for her role as Aunt Etta on the television series *In the Heat of the Night.* Stewart taught speech and dramatic arts at Jackson State University in Jackson and founded Jackson's Repertory Theatre of Mississippi. Repertory Theatre was an African American theater company that focused on bringing to the stage plays by African American playwrights, allowing community members the opportunity to act and giving them the chance to engage in stage design, costuming, and behind-the-scenes work. (Courtesy of Cosmo-D Productions.)

CAST PHOTOGRAPH. Jackson University's *for colored girls who have considered suicide/when the rainbow is enuf: a chorepoem* was written by playwright Ntozake Shange. Shange was born Paulette Williams in Trenton, New Jersey. This powerful play brought to the stage a perspective on what it is to be female and African American in the United States. This photograph shows the cast from the Jackson State University production directed by Dr. Tonea Stewart. (Courtesy of Maxine Jackson and Handy Studios.)

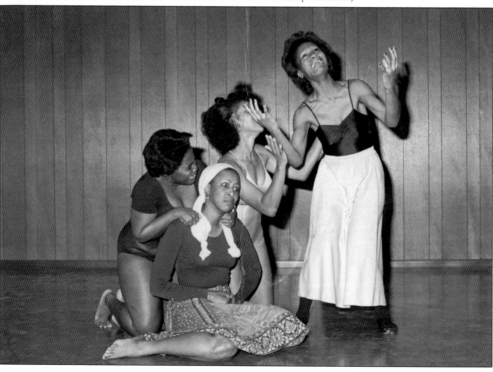

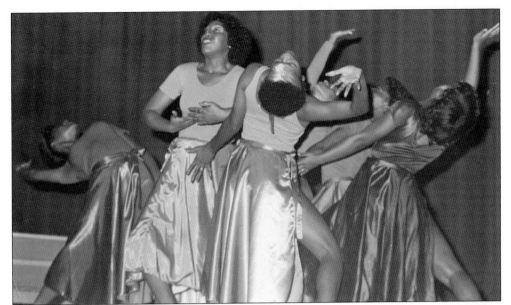

JACQUELINE TERRY. Terry (facing the camera) performs in Jackson State University's production of *for colored girls who have considered suicide/when the rainbow is enuf: a chorepoem*. Popular quotes from the play are, "I found God in myself and I lived her/fiercely," and "I was cold/I was burin up/a child and endlessly weaving garments for moon wit my toes." (Courtesy of Maxine Jackson and Handy Studios.)

THREE LADIES. This image shows the abortion scene in *for colored girls who have considered suicide/when the rainbow is enuf: a chorepoem*. In this scene, the Lady in Red says, "Tubes, table, white washed windows . . . legs spread anxious. I couldn't have people looking at me. Just one day off; get me off of me all this blood/And I didn't say a word, not a sigh, nor a fast scream to get them eyes off of me, git these steal rods out of me. This hurts me. And no one came cause no one knows. Once I was pregnant and ashamed of myself." (Courtesy of Maxine Jackson and Handy Studios.)

CAST FROM FOR COLORED GIRLS. This images shows the cast from Ntozake Shange's play *for colored girls who have committed suicide/when the rainbow is enuf: a chorepoem.* Jackson State University students and members of the Jackson community made up the cast of this production. Dr. Tonea Stewart directed this production of *for colored girls* and many other dramatic presentations at Jackson State. (Courtesy of Maxine Jackson and Handy Studios.)

A RAISIN THE SUN POSTER. This poster was designed by visual artists John Jennings and Lester Julian Meriwether for Tougaloo College's 40th anniversary celebration of *A Raisin in the Sun* by Lorraine Hansberry. Prof. Darius Omar Williams directed this production of *A Raisin in the Sun* at Tougaloo. Williams, a native of Jackson, is an accomplished actor and educator. He was responsible for producing quality community theater during his tenure at Tougaloo College. (Courtesy of Turry Flucker.)

A RAISIN IN THE SUN AT TOUGALOO COLLEGE, C. 1970. This image depicts students at Tougaloo College performing a scene from Lorraine Hansberry's play *A Raisin in the Sun*. This is a pivotal scene in which Mrs. Younger learns that her son Walter Lee's friend has run off with her husband's life insurance money. (Courtesy of Tougaloo College Archives.)

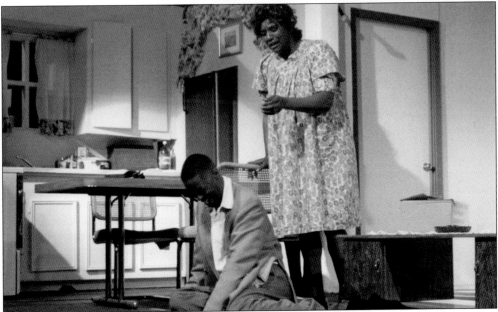

A RAISIN IN THE SUN AT TOUGALOO COLLEGE, 1999. Darius Omar Williams and Frances Horton White perform a scene from Lorraine Hansberry's *A Raisin in the Sun* at Tougaloo College in 1999. The production of *A Raisin in the Sun* directed by Darius Omar Williams celebrated the 40th anniversary of the play's premiere in New York City. (Courtesy of Darius Omar Williams and Lashara Barnwell.)

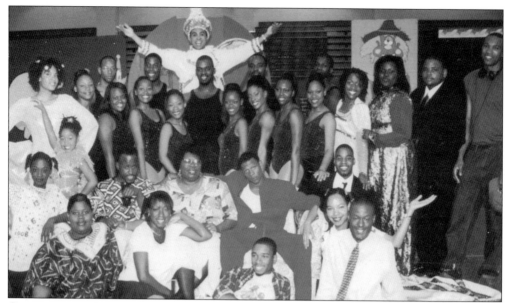

CAST FROM THE TOUGALOO COLLEGE PRODUCTION OF *THE WIZ*. This photograph is of the cast and crew of the Tougaloo College production of *The Wiz*. Directed by Darius Omar Williams, the Jackson production included Tougaloo students and community actors such as Rhonda Chambers as Dorothy, Charles Orr as Scarecrow, Marcus Gilbert as Tin Man, Stephen King as the Lion, Demetra "Deja" McMorris as Glenda the Good Witch, Lannie Spann McBride as Aunt Em, and Turry Flucker as The Wiz. (Courtesy of Turry Flucker and Wesley Williams Sr.)

JESSIE B. MOSELY. Mosely served the Jackson community as an educator and worked tirelessly to establish Smith Robertson School as a museum and cultural center after its official closing in 1971. By 1984, the efforts of Dr. Mosey and Dr. Alferdteen Harrison proved fruitful, when the Smith Robertson Museum and Cultural Center opened its doors as the first institution in the state dedicated to the preservation of the African American experience in Mississippi. (Courtesy of Smith Robertson Museum Archives.)

ALFREDTEEN HARRISON, PH.D. Dr. Harrison is shown looking through literature about the Farish Street Historic District. Dr. Harrison is one of the architects of African American historic preservation in Jackson. Harrison is the cofounder of the Smith Robertson Museum and Cultural Center and is responsible for the placement of the Farish Street Historic District on the National Register of Historic Places. Harrison is a history professor at Jackson State University and director of the Margaret Walker Alexander Research Center at Jackson State University. (Courtesy of Smith Robertson Museum Archives.)

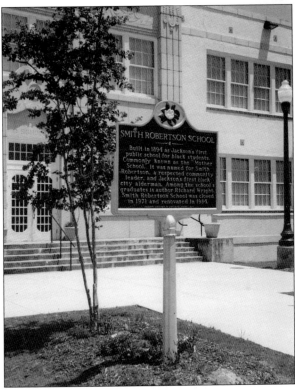

SMITH ROBERTSON MUSEUM STATE HISTORIC MARKER. This exterior shot is of the Smith Robertson Museum and Cultural Center in 2001. In the foreground of the photograph, a Mississippi historic marker commemorates the historical significance of the building as the first public school established in Jackson for African Americans. This maker was purchased through a project headed by Turry Flucker, then curator of Smith Robertson Museum, called "Pennies for History." Local schools were invited to participate in saving pennies that would go toward the purchase of the marker. Three schools in the Jackson Public Schools raised the most pennies— North Jackson Elementary, Power Academic and Performing Arts Complex School, and Davis Magnet School. (Courtesy of Turry Flucker and Jay Johnson.)

MURAL BY LAWRENCE JONES. Jackson State University art professor Lawrence Jones painted this mural. Jones was a native of Lynchburg, Virginia, and arrived in Jackson in 1949. Jones studied in Mexico with muralist Diego Rivera, and he served as the head of the art department at Jackson State University for 30 years. This mural was displayed outside on the grounds of the museum, and it depicts the African American Mississippians' experience. The first panel shows the Native American influence. The second panel highlights Mississippi and the cotton economy. The third shows African Americans working on the railroad, and the last panel shows the industrial age and its impact on the rural American South. (Courtesy of Smith Robertson Museum Archives.)

DAVID MARIO TAYLOR AND VISITORS AT SMITH ROBERTSON MUSEUM. David Taylor, shown on the left near the large wagon, was the first curator at Smith Robertson Museum and Cultural Center. Taylor was a Jackson native and a graduate of Tougaloo College and Carnegie Mellon University in Pittsburgh, Pennsylvania. Taylor was responsible for building the permanent exhibitions at the museum. During his tenure, he was the only professional African American curator in the state of Mississippi. (Courtesy of Smith Robertson Museum Archives.)

EARLY EXHIBITIONS AT SMITH ROBERTSON MUSEUM AND CULTURAL CENTER. This photograph shows an early exhibition at Smith Robertson Museum called the Black Mississippian. This image shows photographs and artifacts of Mississippi politicians such as Rueben V. Anderson, Unita Blackwell, and Alice Clarke. The late David Taylor installed this exhibition. (Courtesy of Smith Robertson Museum Archives.)

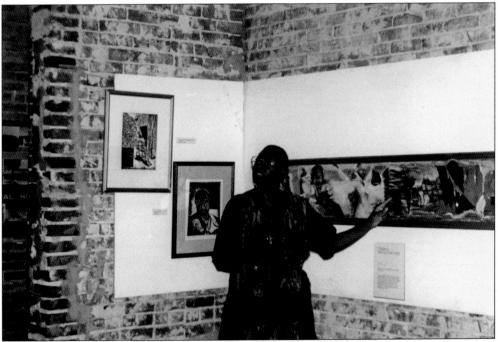

GALLERY TALK. Artist and Tougaloo College art professor Johnnie Mae Gilbert explains her paintings *The Slave Narratives* to the viewing audience. Professor Gilbert is the executive director of the Tougaloo Art Colony, now in its 11th year. (Courtesy of Turry Flucker and Larry Bass.)

TURRY M. FLUCKER AND MUSEUM VISITORS. This photograph shows Turry Flucker, curator of Smith Robertson Museum and Cultural Center, and two patrons visiting the museum. They are standing in front of an installation of a country kitchen and bedroom that interpret African American domestic lifestyles in Mississippi. Before Flucker became curator at Smith Robertson Museum, he served as a docent and part-time curatorial assistant under the tutelage of David Taylor. (Courtesy of Donna Dye.)

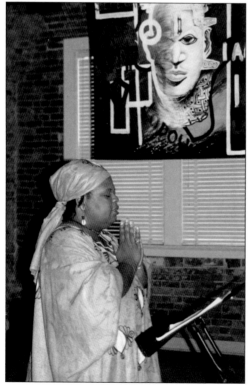

POET WARRIOR. This image shows actress, poet, and educator Jolivette "the Poet Warrior" Anderson performing an original poem at an opening reception at Smith Robertson Museum. Anderson is a native of Shreveport, Louisiana, and spent 10 years in Jackson, where she worked as a community organizer and performance artist. While in Jackson, Anderson worked with many important figures of the black arts and civil rights movements, including Rosa Parks, Bob Moses, Kalamu ya Salaam, Haki Hadhubuti, and the Last Poets. (Courtesy of Turry Flucker and Jay Johnson.)

Hair in African Art and Culture, organized by the Museum for African Art, brings together a collection of over forty objects from Sub-Saharan Africa, including masks and figures, combs, hairpins, beads, headdress, and contemporary African barber shop signs to illustrate the enormous significance of hair within African society.

Throughout the exhibition, the intricately carved hair styles in the artworks mirror the traditional styles worn by men and women.

Photo courtesy of Museum for African Art New York, New York

Smith Robertson Museum and Cultural Center, Jackson, Mississippi is proud to premiere the traveling version of this exhibition:

January 15 - March 10, 2002

Photo courtesy of Museum for African Art New York, New York

HAIR IN ART AND CULTURE. This postcard is announcing the exhibition Hair in African Art and Culture organized by the Museum for African Art in New York. This exhibition brought together a collection of over 40 objects from Sub-Saharan Africa. Jackson was the first city in the Deep South to host this traveling exhibition. (Courtesy of Turry Flucker.)

GWENDOLYN KNIGHT LAWRENCE (1913–2005) AND YOUNG DANCERS. This image shows visual artist Gwendolyn Knight Lawrence at the opening reception of her exhibition A Visual Diary: Works by Gwendolyn Knight Lawrence, organized by Turry Flucker. Lawrence, a former dancer, chats with young dancers that performed at the opening reception at Smith Robertson Museum in 1997. Lawrence is the wife of American painter Jacob Lawrence (1917–2000), who was present at the reception. (Courtesy of Turry Flucker and Larry Bass.)

GATHERED SPIRITS: EMERGING VISUAL ARTISTS INSTALLATION. This photograph shows an art installation by Phoenix Savage called *VeVe* that is featured in the exhibition Gathered Spirits: Emerging Visual Artists. This exhibition was presented at Smith Robertson Museum in 1997. (Courtesy of Turry Flucker and Jay Johnson.)

GATHERED SPIRITS: EMERGING VISUAL ARTISTS GROUP. Shown are the visual artists that participated in the exhibition Gathered Spirits: Emerging Visual Artists. Pictured from left to right are Wesley Hargon, Phoenix Savage, Rachel A. Dolezal, and Kenyatta Stewart. (Courtesy of Turry Flucker and Jay Johnson.)

KENYATTA STEWART AND RACHEL A. DOLEZAL. This shows two paintings featured in Gathered Spirits: Emerging Visual Artists. On the left hand side is a large painting by Kenyatta Stewart, and hanging next to the Stewart's paining is a leather sculpture by Rachel A. Dolezal. (Courtesy of Turry Flucker and Jay Johnson.)

THE BUFFALO SOLIDER: THE AFRICAN AMERICAN SOLDIER IN THE UNITED STATES ARMY, 1866–1912. This exhibition was the opener for the 2000 exhibition program season at Smith Robertson Museum. Anthony L. Powell of San Jose, California, organized the exhibition, and it consisted of vintage photographs and artifacts that depicted the African American in the military during the later part of the 19th and early 20th centuries. In this photograph, James Powell gets his program booklet autographed by guest curator Anthony L. Powell at the opening reception. (Courtesy of Turry Flucker and Charles A. Smith.)

TRAVELING EXHIBITION. This is an installation photograph of the traveling exhibition organized by the Museum for African Art in New York. Smith Robertson Museum played host to this exhibition in 2001, which pays tribute to women of African decent from all over the world chronicled by world-renown photographer Chester Higgins. (Courtesy of Turry Flucker and Charles A. Smith.)

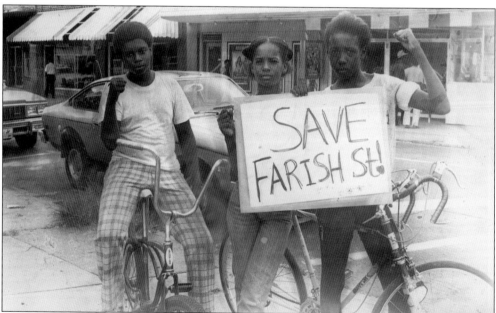

SAVE FARISH STREET. This photograph, taken around 1970, shows three African American youths holding up a sign that reads, "Save Farish Street." Due to integration, the Farish Street community has remained blighted for a number of years. Concerned citizens have banned together to preserve the history of the district. It is extremely important that city developers save Farish Street for the simple reason that the loss of Farish Street is the loss of the history of the African American experience in Jackson, Mississippi. (Courtesy of Cosmo-D Productions and Hollis Watkins.)

BIBLIOGRAPHY

Bailey, Ben. "Opera/South: A Brief History." *Black Perspectives in Music* Vol. 13, No. 1 (1985): 48–78.

Branch, Taylor. *At Canaan's Edge: America in the King Years 1965–68*. New York: Simon & Schuster, 2006.

Bowman, Rob. *The Last Soul Company*. Jackson: Malaco Records, 1999.

Communication Arts. *Jackson: Civil Rights Movement Driving Tour*. Jackson, MS: Jackson Convention and Visitors Bureau, 2003.

Dalehite, William. *A History of the Public Schools in Jackson, Mississippi 1832–1972*. Jackson: Board of Trustees, Jackson Public Schools, 1974.

Dittmer, John. *Local People: The Struggle for Civil Rights in Mississippi*. Urbana, IL: University of Illinois Press, 1995.

Harrison, Alferdteen. *Piney Woods School: An Oral History*. Jackson: UP of Mississippi, 1982.

Mosley, Jessie. *The Negro in Mississippi History*. Jackson: self-published, 1969.

Pittman Middleton, Mabel. *The Central Connection: A History of the First One Hundred Years at Central United Methodist Church*. Jackson: Town Square Books, 1998.

Raines, Howell. *My Soul is Rested: The Story of the Civil Rights Movement in the Deep South*. New York: Penguin Books, 1977.

Sewell, George. *Mississippi Black History Makers*. Jackson: UP of Mississippi, 1984.

Wharton, Vernon. *The Negro in Mississippi 1865–1890*. New York: Harper & Row, 1947.

Wright Richard. *Black Boy*. New York: Harper, 1954.

www.arcadiapublishing.com

Discover books about the town where you grew up, the cities where your friends and families live, the town where your parents met, or even that retirement spot you've been dreaming about. Our Web site provides history lovers with exclusive deals, advanced notification about new titles, e-mail alerts of author events, and much more.

Arcadia Publishing, the leading local history publisher in the United States, is committed to making history accessible and meaningful through publishing books that celebrate and preserve the heritage of America's people and places. Consistent with our mission to preserve history on a local level, this book was printed in South Carolina on American-made paper and manufactured entirely in the United States.

This book carries the accredited Forest Stewardship Council (FSC) label and is printed on 100 percent FSC-certified paper. Products carrying the FSC label are independently certified to assure consumers that they come from forests that are managed to meet the social, economic, and ecological needs of present and future generations.

FSC
Mixed Sources
Product group from well-managed forests and other controlled sources

Cert no. SW-COC-001530
www.fsc.org
© 1996 Forest Stewardship Council

Find Your Place in History.